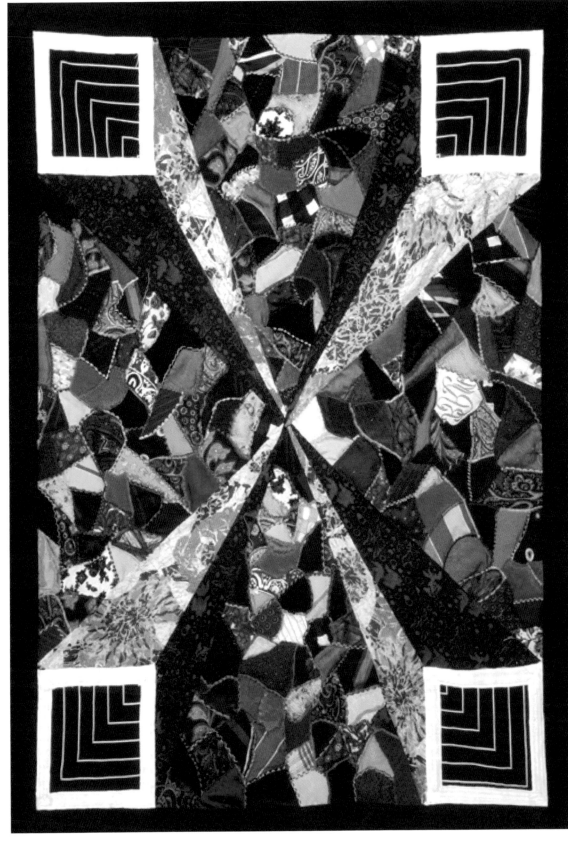

PIONEERING QUILT ARTISTS, 1960-1980

A New Direction in American Art

SANDRA SIDER

Frontispiece: Beth Gutcheon, *Pace Victoria* (1972, 50 x 39 in.).

ISBN: 145157679X
ISBN-13: 9781451576795
LCCN: 2010904614

Dedicated to my amazing grandchildren, in order of appearance:

Molly May Shayne

Nora Elizabeth Shayne

Johnny Trotter Sider

Sinjin David Sider

TABLE OF CONTENTS

PREFACE

The 1960s and 1970s were pivotal years for American quiltmaking, as full of exuberant exploration and unfettered experimentation as the times themselves. Responding to a variety of societal changes and aesthetic stimuli, a number of formally trained artists began making quilts during these two decades, and, for the first time, the world of academic art began looking at antique American quilts as objects of real artistic merit, not merely domestic handcraft. Some of the artists who took up the quilt as their medium of choice thirty or more years ago continue to be creative forces who are pushing the envelope of quiltmaking, but many others have faded into history as time has passed, their contributions largely unknown to today's practitioners and obscured by the commercialism that too often drives the contemporary scene.

But history matters, and that scene has a long and rich backstory that deserves to be told and remembered. Happily, quilt artist and scholar Sandra Sider has taken the time to look back and thoroughly explore the early years of what has come to be called "the art quilt." She has located and communicated with forgotten and neglected artists, ferreted out a host of obscure publications, and probed the memories of artists whose commitment to the quilt medium extends over many decades. The result is a study that will enrich the understanding and appreciation of anyone who cares about American quilts and quiltmaking. I commend it particularly to contemporary artists, both for the historical background it fills in and for the inspiration and knowledge they can draw from the women and men who helped to create the world they now inhabit.

Robert Shaw
Shelburne, Vermont

ACKNOWLEDGEMENTS

Many people richly deserve to be thanked for their contributions to this book, which has been nine years in the making. I truly feel that it has been a collaborative effort. First and foremost to be thanked are the dozens of artists who took the time to respond to my rather lengthy survey, and all those who have permitted me to publish images of their work.

I am especially grateful to Nancy Halpern for sharing the text of her unpublished 1983 book-length manuscript *Northern Comfort: Three Hundred and Fifty Years of New England Quilts.* Her contemporary account of events and attitudes of the 1970s has been invaluable. Another important resource was *String, Felt, Thread: The Hierarchy of Art and Craft in American Art* by art historian Elissa Auther, published in 2010 by the University of Minnesota Press. This excellent book offers an extensive account of the presence of fiber in American art from the latter 1960s through the 1970s. The author generously shared her unpublished manuscript with me.

Numerous friends and colleagues have kept me going with their encouragement, notably Robert Shaw, who kindly offered to write the preface. His publications have been both an inspiration and a challenge. I cannot begin to list all those who stopped in the midst of various projects to answer my queries, including Teresa Barkley, Nancy Crow, Karey Bresenhan, Michael James, Jean Ray Laury, Paula Nadelstern, Yvonne Porcella, and Joan Schulze. In addition, James let me read through his private archives from the 1970s, which helped situate me in the studio quilt movement near its beginning. I am also grateful to Penny McMorris, who wisely suggested that I focus on the artists' narratives.

Finally, I am eternally grateful to my husband of forty years for his endless patience and support.

INTRODUCTION

This book was undertaken to satisfy my own curiosity concerning how quilts became a form of contemporary art that originated in the United States.[1] By "quilt art" I mean layered compositions stitched in fabric or fabric-like material for display on the wall. While I have enormous respect for traditional quiltmaking, or "contemporary mainstream," as it is now being called, my book does not consider quilts in that mode. Nevertheless, I hope that traditional quiltmakers and their collectors will find much to interest them in this book.

The term used here for quilts as contemporary art is "studio quilt," which alludes to an artist or group of artists working to create a work of visual art for the wall or other nonfunctional display. During the decades of the 1960s and 1970s, studio quilts were described in the press as "modern," "contemporary," or "non-traditional" quilts.

My date span of 1960-1980 is a bit loose, in that a few quilts and events dating prior to 1960 and just after 1980 are mentioned. The majority of the text and images focuses on the 1970s, the decade in which quilts as art made significant leaps and studio quilts were exhibited in some important exhibitions. As Robert Shaw has noted about quilt artists in the 1960s, "For the most part, they worked for their own satisfaction, unaware of each other. Their work was a series of isolated gestures reaching toward something new and unknown."[2]

Narratives from the artists themselves comprised the foundation of my research, formulated from surveys filled out between 2001 and 2008 (see Appendix II for the questions), and from numerous phone interviews. This is not an art history textbook, but rather a documentation concerning artists' history. The selection of artists was intended to create a representative sampling of diverse styles of quilts, and of artists from different regions. Artists' words not footnoted are from the surveys. This primary material has revealed a wealth of information from the two decades studied, suggesting how quilts developed as contemporary art.

This book is meant to be representative rather than comprehensive, which means that several quilt artists do not have quilts illustrated, even though their work contributed to the development of quilts as contemporary art. I can only hope that they might understand the necessary lapses in a book attempting to cover so much ground. I focused on artists known for producing quilts before 1980, which omitted many later quilt artists who were working in other media during the period covered by the present book.[3]

In Nancy Halpern's words about quilt artists in the latter 1970s, "… at our best we are a highly individualistic group, drawing from a great eclectic melting pot of art, design, and subject matter, filtering these influences through the network of our inner spirits."[4] My book is a journey back in time, exploring how it all began.

1 "American" throughout the book refers to artists working in the U.S.A. The scattered foreign artists working in quilt art during the 1960s and 1970s have not been considered.

2 Robert Shaw, "Five Decades of Unconventional Quilts" [1960s], *Quilter's Newsletter Magazine*, 2004, vol. 35 (no. 1), p. 44. I am extremely grateful to Teresa Barkley for her encouragement, and especially for allowing me to conduct research in her home to study her comprehensive collection of this magazine.

3 An excellent example would be Arlé Sklar-Weinstein, now internationally known for her quilt art. She earned an M.A. in Art at New York University, mentored by Hale Woodruff, a noted artist of the Harlem Renaissance. Sklar-Weinstein was working in fiber art during the latter 1970s, exhibiting wound-wool sculptural tubes titled *Rainbow Colonies*, and beginning to experiment with fabric to interpret her drawings and collages.

4 Nancy Halpern, *Northern Comfort: Three Hundred and Fifty Years of New England Quilts* (unpublished typewritten manuscript, completed in 1983), Chapter X, pp. 7-8.

CHAPTER 1:
BECOMING A QUILT ARTIST

GETTING STARTED

The first stage in becoming a quilt artist during the 1960s and 1970s was, for most people, learning how to make a quilt. This skill was accomplished with publications, workshops and other classes, knowledge from family members or friends, and individually by trial and error (usually with lots of error). The instructions now available via television and video for beginning quiltmakers existed sporadically, but only after the mid-1970s.[5]

A few artists working in the quilt medium, such as Charles and Rubynelle Counts and Ed Larson [Fig. 1], never learned how to quilt, but rather hired others to quilt their designs. Although they did not handle a needle and thread for their artwork, these individuals created compositions in which the stitching was considered the final element of design.[6]

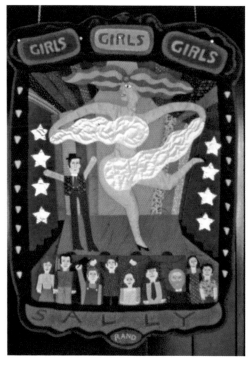

Fig. 1. Ed Larson. *Girls, Girls, Girls* (1970s, 45 x 32 in.), quilted by Carolyn Crusian. The artist, who saw Sally Rand perform her famous fan dance in St. Louis, inserted a self-portrait above the "Y" in her name. Rand's size in relation to the other figures exemplifies Larson's folk-art style, in which hierarchy of scale distinguishes the heroic subjects of his quilts.

Publications: Books

Most useful for beginners were books that included patterns, measurements, quilting instructions, and photographs of completed quilts.[7] This section of Chapter One is a survey of some of the books and magazines cited by quilt artists via e-mail, letters, phone conversations, and personal interviews as having helped them first learn to make quilts during the 1960s and 1970s. Among the most popular books during the 1960s was *101 Patchwork Patterns* (1931, numerous later printings) by Ruby McKim. The Dover reprint of this book in 1962 joined the publisher's list of thirteen other books on patchwork. McKim wrote her book in a direct, relaxed style, assuring the reader that anyone could make a quilt. The introduction notes that many quiltmakers were young women with "unspoiled imaginings"—implying that modern young women could also participate "in the game of quiltmaking" (p. 3).[8] *101 Patchwork Patterns* was an important book for many quilt artists, including Joan Schulze, especially when she first began to teach quiltmaking.

Another very successful Dover reprint was *The Standard Book of Quilt Making and Collecting* (1949, Dover 1959) by Marguerite Ickis. Although this book focused on designated patterns, the chapter on "The Quilt's Design and Its Parts" includes a paragraph on "Making Your Own Design"—probably one of the earliest such texts concerning quiltmaking to appear in print. Ickis suggested taking a piece of paper the size of the block you wish to have, then folding it through the center twice to form four smaller squares, marking with a pencil or cutting randomly with scissors to produce a design template when the paper is unfolded. She also recommended copying the figures from a print dress or necktie, and enlarging them. This section closes with a word of encouragement for those contemplating original designs: "There is no limit to design sources, if you have ideas and imagination" (p. 25).[9] This sort of encouragement was invaluable during the 1960s when quiltmakers had few resources for original designs.

Donna Renshaw has been mentioned as an influence, including her publications on quilting, such as *Quilting, A Revived Art: Cultivate the Art of Making Something with Your Own Hands,*[10] published c. 1975. Her Chapter One begins: "Quiltmaking is an art. It follows close to painting, spinning, weaving, mosaics and all types of arts and crafts." Renshaw viewed quiltmaking as a woman's art, situating it firmly in women's history and targeting her book toward women in the home. Although her book is a step-by-set manual, the text focuses on process and not on patterns. She encouraged originality in design: "One nice thing about quiltmaking, you can use your own imagination and do anything you wish to do, along with bringing out your creativity, or the nonconformity you've always had a longing for."[11] Women who worked as homemakers were encouraged by such comments to pursue quiltmaking as a creative outlet, to relieve the presumed boredom of their daily lives.

The editors of Sunset Books issued a useful series of books on quiltmaking, such as *Quilting and Patchwork*, first published in 1973, with six printings by the end of 1974.[12] Paula Nadelstern learned how to quilt from a Sunset book, as did Carolyn Mazloomi.[13] Although *Quilting and Patchwork* mostly offered preconceived projects, a few of the works illustrated were avant-garde quilts, such as those quilts designed by Charles and Rubynelle Counts, and Joan Lintault. "How To Create an Unusual Quilt" (p. 58) must have piqued the curiosity of many readers with its list of "eighteen capsule ideas…using a variety of techniques" in printing, freehand (e.g., painting and batik), and needlecraft (e.g., collage and lettering).

Michael James found the books by Averil Colby, among others, to be very helpful when he was learning to make quilts [Fig. 2].

Fig. 2. Michael James. *Razzle-Dazzle* (1975, 96 x 84 in.).

Colby's book titled simply *Patchwork* (first published in 1958) is filled with precise instructions for every stage of quiltmaking, with occasional aesthetic comments accompanying the practical information. For those just learning how to quilt, even the most basic steps could present a problem. Caryl Bryer Fallert was among those who began making quilts by leaving 5/8-inch seams, quickly realizing that this was too much fabric on the back of the quilt.[14]

Condé Nast Publications joined the quilt bandwagon, with books such as their *Vogue Guide to Patchwork and Quilting*.[15] This 1973 book included not only patterns, but also illustrations of entire rooms (including a lampshade) busily decorated in patchwork designs, as well as a frontispiece of Gloria Vanderbilt "the painter, photographed in her beautiful all patchwork bedroom ... [showing] how patchwork can be really dazzling for interior decoration" (caption, p. 5). On the same page, the editor encouraged readers to make quilts from new fabric because "this means that a modern patchwork can be designed from start to finish."[16] This how-to book included brief discussions of basic shapes for patchwork, with useful design information: "By using contrasting tones and very simple shapes it is quite easy to achieve some extraordinary optical illusions ... by changing the layout of the triangles, but still using dark and light fabrics, you can get a fractured effect" (p. 20). This "fractured" approach would be one of the techniques by which several contemporary quilt artists, such as Marie Lyman [Fig. 3] and Molly Upton [Fig. 4], made the leap from quilter to quilt artist.

Fig. 3. Marie Lyman. *Dream of White Horses: Rock, Sky, Sea* (1975, 81 x 51 in.).

Fig. 4. Molly Upton. *Watchtower* (1975, 90 x 110 in.).

Publications: Periodicals

Magazines marketed to women, *The Progressive Farmer*,[17] various newspapers, and other periodical publications featured quilt projects, usually a pattern or patterns that readers were expected to copy faithfully. A few new magazines in the 1960s and 1970s were created specifically for quiltmakers, such as *Quilters' Journal*, published between 1977 and 1987, edited by Joyce Gross.[18] The articles discussed technique as well as quilt history. One of the most popular magazines created for quiltmakers, *Quilter's Newsletter Magazine*, began its publication in 1969 (as *Quilter's Newsletter*), edited by Bonnie Leman.[19] Some of the quilts by artists featured in the present book first appeared in print in *QNM*.

Lady's Circle Patchwork Quilts, a magazine coedited by Carter Houck and Janet Chill, gave potential quilt artists a balanced presentation of original designs and patterns. Issue no. 14 (1979), for example, published an article by Beth Gutcheon on "The Quilts of Molly Upton as Works of Art" (pp. 6-11, 71) that included illustrations in color. The editors were careful to distinguish between original designs and patterns: "When patterns are not included, it is due to the fact that these are personalized designs and belong to the makers of the quilt" (p. 3).

McCall's was among the women's publishers dominating the field of quilting and patchwork, issuing several books and magazines in which garments were emphasized as much as quilts to support the McCall Pattern Company. Interestingly, the surface designs for garments often were rather avant-garde, while most of the quilt patterns remained relatively traditional. The editors of McCall's Needlework & Crafts published a series of books titled *Quilt It!* with the second book issued in 1972 and reprinted in 1973 and 1974. *McCall's Contemporary Quilting* (1963, with eight new editions through 1975) featured dynamic original quilts by such artists as Barbara McKie and Virginia Avery, but with the expectation that readers would copy their designs.

Workshops and Other Classes

Neophyte quiltmakers could learn the basics in workshops and classes if they happened to live near a facility where such instruction was offered,[20] or could afford to travel.[21] A few educational institutions included fiber as part of their art or crafts curriculum, such as the Cranbrook Academy of Art (Bloomfield Hills, Michigan) and the Oregon School of Arts and Crafts (Portland),[22] but not all of them offered quilting per se. Marie Lyman was among those teaching quiltmaking at the Oregon School of Arts and Crafts in the latter 1970s,[23] but Cranbrook never had a formal class in quilting or quiltmaking in the 1960s or 1970s. Gerhardt Knodel, director of Cranbrook from 1970 until 1996, explains: "... because the nature of the graduate program is to support individual courses of study determined by each student, there were some students who used the conceptual framework of quiltmaking and its techniques in their work. Most of that experimental work was useful in enhancing appreciation of the legacy of quiltmaking, and in stimulating ideas about the potential for integrating aspects of the practice into new innovative forms of expression."[24]

Quilt art pioneer Alma Lesch taught textile arts at the Louisville School of Art (Kentucky) beginning in 1961. Like Lyman and a few other quilting teachers during the 1960s and early

1970s, Lesch traveled and presented workshops. Betsy Cannon, a quilt artist since 1968 known for her embellished pictorial quilts, remembers the interesting experience of studying quilt-making with Lesch in the mid-1970s at the Arrowmont School of Arts and Crafts (Gatlinburg, Tennessee). Lesch also taught at the Haystack Mountain School of Crafts (Maine), a facility mentioned as influential for several artists during their early years of making quilts or learning other crafts involving textiles. The Penland School of Crafts in western North Carolina provided instruction in fiber that included quiltmaking; Terrie Hancock Mangat is among the contemporary quilt artists who profited from workshops taken there.

Jeanne Williamson has a 1978 BFA in Fibers and Crafts from the Philadelphia College of Art, where she began by majoring in jewelry, weaving wire for her pieces and taking elective courses in the Fibers Department. She took a class in quilting, in which the students used templates for cutting patterns and learned fine hand quilting, not being permitted to make any knots in the thread. Williamson stresses that "the quiltmaking we did then was *very* traditional, with no creativity except for the colors we paired together."[25] She found a more appealing way to work with fabric in stitched collage. In some schools, quilting was offered under the rubric of needlework. Studio classes in fiber art could be found cross-listed with the fledgling women's studies program of the 1970s,[26] a result of the feminist movement (see Chapter There).

Several artists have mentioned the early workshops of Jinny Beyer (sometimes given in her home) as a formative influence on their quiltmaking skills, especially in the technique of drafting patterns. Jane Hall, for example, studied compass drafting in one of her classes. Beyer's 1979 book *Patchwork Patterns*, which defines geometric patterns by categories based on a grid system, was rather traditional in its approach. But the final chapter of Beyer's book, "Original Design," voices ideas presented in her classes that were useful for students attempting to create their own designs, such as not planning the entire quilt at once, but rather working with the fabrics, turning the blocks different ways, and appreciating that a "whole new dimension" can result in the interplay of fabrics (p. 177).[27]

In 1971 Beth Gutcheon began offering quilting workshops in New York City, and "quickly became the most prominent teacher on the East Coast."[28] She and her musician-husband Jeffrey Gutcheon created original quilts based on unique variations of vintage blocks, displaying them in their loft at 510 Broadway, where she conducted workshops and sold fabric. By the spring of 1972, Gutcheon had numerous students and was becoming well known, partly thanks to press coverage such as an illustrated article by Rita Reif in the *New York Times*.[29]

CREATING ORIGINAL DESIGNS

Publications: Books[30]

The earliest book on contemporary quilt art viewed as an important source for artists whom I contacted is Jean Ray Laury's groundbreaking 1970 *Quilts & Coverlets: A Contemporary Approach* [Fig. 5]. This 128-page publication promotes contemporary quilts, such as a Tracey Emin-like construction with lettering and text by Stephanie Cyr (p. 46), several modernist quilts in color by Charles Counts and the Rising Fawn Quilters (pp. 60-61, 63), and Joan Lintault's

famous conceptual piece *La Chola en la Colcha*, in which a stuffed figure in a pieced "garment" appears to be swelling out from under the quilt (p. 64).

Fig. 5. Jean Ray Laury. *Tom's Quilt* (1956, 74 x 50 in.). The artist's first piece of needlework, in which she learned to appliqué and quilt, was made for her four-year-old son as part of her graduate thesis at Stanford University. It led to a commission for Laury's first magazine article (*House Beautiful*, 1960).

Many of the images in Elsa Brown's book *Creative Quilting* (1975), resonate with contemporary and near-contemporary works in the world of what was then called "fine art," beginning with Romare Bearden's collaged painting *Patchwork Quilt* (c. 1972),[31] in which he incorporated scraps of fabric. Other provocative works were a fantasy landscape by Helen Bitar (p. 65), a piece by Kathryn McCardle Lipke featuring knotted rope reminiscent of the art of Eva Hesse (p. 80), and *Man Pyramid* by Lenore Davis (p. 122), which quivers with the energy of a Keith Haring drawing. Brown's introduction informed the reader: "fabric has become an important sculptural medium for relief as well as three-dimensional forms. Many artists who formerly worked with more traditional materials have turned to cloth to create imaginative wall hangings, dolls, sculptural objects, and body coverings...." (p. 10) [Fig. 6].

Fig. 6. Helen Bitar. *Mountain in the Morning* (1976, 106 x 83 in.).

Quiltmaking: The Modern Approach to a Traditional Craft (1972) was a how-to book by painter and sculptor Ann Sargent-Wooster, whose credentials included classes at Parsons School of Design and the School of Visual Arts in New York [Fig. 7]. Her introduction informed the reader: "Recently, many painters, sculptors, and designers have been turning to soft materials to create their designs."[32]

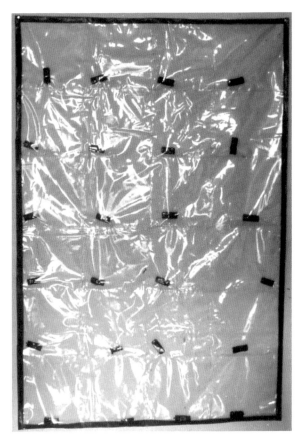

Fig. 7. Ann Sargent-Wooster. *Stolen Cars* (1972, 60 x 41 in.). An example of non-textile materials used to create a postmodern quilt-like structure.

The images of avant-garde quilts and fabric sculptures included Nell Booker Sonnemann's six-foot-high *Woman Clothed with the Sun* (p. 158, [Fig. 8]); she described her three-dimensional forms as "appliqué ... moving into open space" (p. 157).[33]

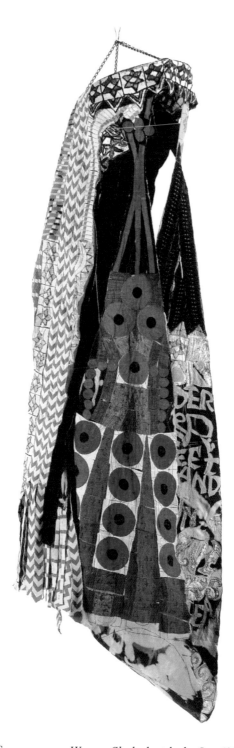

Fig. 8. Nell Booker Sonnemann. *Woman Clothed with the Sun* (1972, 72 x 30 x 24 in.).

Thelma R. Newman's purpose in writing *Quilting, Patchwork, Appliqué, and Trapunto* (1974) focused on "one's own ability to create original and personal forms."[34] Along with illustrations of original artwork by contemporary artists in the United States, she featured ethnic textiles from Africa, India, and Panama, important design sources for some quilt artists during the 1970s. The contemporary quilt art in this book was extraordinary, including *The Point*, a semiabstract fabric collage by Bets Ramsey (facing p. 25) and Margaret Cusack's Warhol-like fabric portrait of Aldous Huxley (fourth page of color figures following p. 24). Many of these works were innovations on the part of the artists—their newest pieces, some never before published. Bets Ramsey has recently remarked concerning *The Point*: "I was trying some new ideas and they seemed to work."[35]

The Complete Guide to Quilting (1974) by Audrey Heard and Beverly Pryor also promoted quiltmaking as contemporary art, cautioning readers to learn basic techniques (which were included) before venturing into original designs. The authors explained their purpose in writing the book: "It gives us great pleasure to see quilts hung on walls, serving as decorative focal points in the manner of paintings. Excitement of color and harmony of design should be the goal of every person who puts needle to cloth."[36] The illustrations juxtaposed traditional pieced and appliquéd quilts, along with others in pictorial folk-art style, with several modernist works, such as quilts in op art style by Barbara McKie (p. 191) and Sharon McKain (p. 205).

Quilt artists who were active in the 1970s have cited several other books as instrumental in their creative development. Near the top of the list of all these books would be *The Perfect Patchwork Primer* (1973) by Beth Gutcheon; *The Quilt Design Workbook* (1976) by Beth and Jeffrey Gutcheon; *The Quiltmakers Handbook: A Guide to Design and Construction* (1978) by Michael James; and *The Second Quiltmakers Handbook: Creative Approaches to Contemporary Quilt Designs* (1981), also by James.[37] Not only did these books encourage originality, but they also provided basic patterns that readers could expand and alter. Moreover, the Gutcheons and Michael James offered workshops conducted with a relaxed yet involved attitude, with the teachers carefully explaining the lessons in their books. Katie Pasquini Masopust says, "Michael James transformed my high school art knowledge to art quilts."

Because Gutcheon's book appeared relatively early, and in the popular Penguin Handbook series, and possibly because of her positive exposure in the press, this publication was extremely influential. *The Perfect Patchwork Primer* was, in fact, one of the first how-to books on quiltmaking used by Michael James in the mid-1970s. Most importantly, it was written from the point of view of a quiltmaker who viewed the craft as having the potential of an art form, who assumed that the satisfaction of creating quilt art "lies in the realm of aesthetics and self-expression ... to push the tradition a step forward, to say something new about ourselves, and about quiltmaking."[38] In addition to depicting quilts by the Gutcheons, *The Quilt Design Workbook* included images of several innovative abstract quilts by Susan Hoffman and Molly Upton, inspirations to anyone beginning to work with quilts as art.

The Quiltmaker's Handbook (1978) by Michael James gave readers a clear, detailed Appendix titled "On Color in Quilts," based on his experience as a painter and referring to the color theories of Josef Albers; the twenty-one color plates illustrated some of

these concepts. Like the Gutcheons, James wrote a book that could be used in workshops (see below). The author praised quiltmaking from a philosophical point of view, as a "tangible means to reaffirm our individualities and creative capabilities" in a highly automated world.[39] The introduction also affirmed quilts as art: "... in our general recognition of quiltmaking as an *art* form, we have come to acknowledge its rightful place as one of many sophisticated modes of visual expression" (p. 2). Artists of the 1970s who simply ignored the futile "art versus craft" controversy experienced how "new technical challenges imposed by different design considerations create ... a vital interchange between craft and art" (p. 3). Instructions in James's book, written by a recognized virtuoso of the genre, allowed students to balance precision with spontaneity. *The Quiltmaker's Handbook* appeared at a fortuitous moment in American quilt history, in that numerous potential quiltmakers (mostly women) had been inspired by the United States bicentennial celebrations in 1975-1976, which included quilt exhibitions and publications (see Chapter Two). They were eager for more information.

Almost all of the helpful books published before the early 1980s were how-to books, which makes sense because people were trying to learn how to deal with quilts as an artistic medium within the limitations of structural fabric. But in 1978, a remarkable publication by Pattie Chase and Mimi Dolbier, definitely not a how-to, caught the attention of virtually everyone working with quilts as art. Sue Benner and Robin Schwalb, for example, cite this book as being of tremendous influence on their early work. Titled *The Contemporary Quilt: New American Quilts and Fabric Art*, it brought quilt art into the limelight, exploding on the scene with a monumental eye surmounting a flamboyant pyramid in a 1976 quilt by Sas Colby on the front cover, and Jody Klein's fantastical, three-dimensional interpretation of stars and stripes in *Bumpy Quilt* (1973) on the back. The former featured photo transfer; for the latter, the artist used hand-dyed fabric. Susan Hoffman's architectural tour-de-force *Spires, Coutances Cathedral* (1975) graced the half-title, and Molly Upton's majestic *Torrid Dwelling* (1975) served as the frontispiece. Every work in the book was illustrated in color, highlighting the significance of quilts as art.

One other how-to book concerning quilting was an interesting source for several artists: Pauline Chatterton's *Patchwork & Appliqué* (1977). A British fiber artist, Chatterton had previously published two books on crochet, and the innovative aspect of her latest publication was that not only did she explain how to make quilts, but she also explored how the designs of quilts could be translated into knitting, crochet, and bargello needlework. The chapter titled "Inspiration for Appliqué" included abstract quilts by Michiko Sato (p. 47), Sas Colby's quasi-psychedelic figural quilt inspired by a Beatles song and created partially with photographic printing (p. 48),[40] and abstract Mylar quilts by Patricia Malarcher (pp. 49-50). This book helped stimulate quilt artists to experiment with new materials, techniques, and processes.

Embellishing a quilt surface usually was referred to as "stitchery" during the 1960s and 1970s, with several books on this topic inspiring artists to learn embroidery and other types of freehand needlework. Three books evidently were especially useful to quiltmakers. The goal of *Adventures in Stitches: A New Art of Embroidery* (1949) by Mariska Karasz was to instruct

the reader how to "develop into a painter in thread."[41] The author, who had solo exhibitions in New York City, was also known as a clothing designer. The linear embroidery of Karasz inspired B. J. Adams early in her career as a quilt artist. David van Dommelen also used the word "art" in the title of his 1962 book *Decorative Wall Hangings: Art with Fabric.*[42] Known chiefly as a designer, the author had this to say about his work: "My field of concentration in wall hangings contributes as much to the Fine Arts as does contemporary painting....To me, the stitch ... has as much message as the stroke of a brush. I find myself in a medium that is completely unexplored, ready to be discovered and opened to the world" (p. 178). Artists with fiber art illustrated in this book include Alice Adams, Jean Arp, Mariska Karasz, Jean Ray Laury, Marilyn Pappas, and Frances Robinson.

By far the most influential book of stitchery for quilt artists of the 1960s and 1970s was Jean Ray Laury's *Applique Stitchery* (1966), with many of the images showing quilted appliqué, all in examples made by the author herself. More importantly, Laury stressed idea and design much more than technique, assuring readers that simple techniques executed with basic equipment could express interesting concepts. For Laury, stitchery "means much the same as needlework, but avoids the connotation of stamped patterns, directions, and limitations."[43] She advised readers to begin by becoming involved with an idea and an attitude: "The idea or intellectual content will give a work its validity; the attitude or emotional content gives it its strength; the act or physical involvement gives it its form. This is true in all media."[44]

Finally, "soft art" was becoming a popular alternative art form during the 1970s, with *Stitched and Stuffed Art: Contemporary Designs for Quilts, Toys, Pillows, Soft Sculpture and Wall Hangings* (1974) by Carolyn Vosburg Hall epitomizing the diverse aspects of this genre.[45] Some of the contemporary quilts and quilt-like structures were by Alma Lesch, Bonnie Gisel (four-patch squares wired together, with the piecing seams turned outward), and Gwendolyn Hogue (tie-dyed silk quilted to burlap). The author, who had been an art critic for ten years, had an M.F.A. from the Cranbrook Academy of Art. The book quickly became known, possibly because the noted crafts critic Lisa Hammel gave it a positive review in the *New York Times.*[46] The back flap of the dust jacket states, "the author has helped to dispel the artificial distinction between arts and crafts."

Publications: Periodicals

While books might reach an audience of a few thousand readers, many periodicals had circulations into the tens of thousands. In addition to her books, Jean Ray Laury influenced new quilt artists through her articles and images of her quilts published in periodicals [Fig. 9].

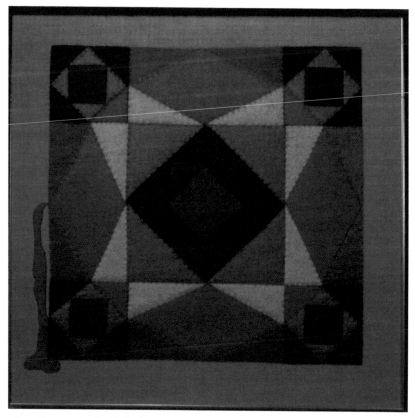

Fig. 9. Jean Ray Laury. *Leaky Kaleidoscope* (1978, 23.5 x 23.5 in.). This piece, which spoofs the obsessive perfection in many traditional quilts, is constructed of heavy-duty wool felt.

Yvonne Porcella was among the numerous artists struck by this work—Laury's writing as well as her quilts—in *Family Circle Magazine* and other publications. Laury's quilts were featured on several covers of *Family Circle* during the 1970s, and a brilliant red comforter by Laury appeared in an issue of *Cosmopolitan*, covering a presumably nude couple involved in lovemaking, with the caption "Quilt a Sensuous Quilt"—a surprisingly hip, new image for quilts.[47] Laury's first published article, and the one she considers "most important,"[48] appeared in a 1960 issue of *House Beautiful*. We shall discuss it in Chapter Three. In 1979 *Quilt World* published an image of Laury quilting on its cover, with a feature article titled "A Heart-To-Heart Talk with … Jean Ray Laury."[49] The article summarized her success as an author and quilt artist, indicating the various means by which Laury had achieved her current status. This text and others like it provided those attempting to be quilt artists with successful role models.

As mentioned above, *Lady's Circle Patchwork Quilts* published an article by Beth Gutcheon on "The Quilts of Molly Upton as Works of Art" in 1979 that included illustrations in color. Although other periodicals had mentioned, or even featured, quilts as contemporary art, few readers had seen anything like the extraordinary graphic quilts by Upton and Susan Hoffman—especially not in a *Lady's Circle* publication. The influence of these images was far-reaching. Valerie Hearder shared this memory from South Africa: "In 1972 I was 20 and living in South

Africa when I taught myself to make quilts based on English paper piecing. ... There was no established history of quiltmaking in South Africa so batting or quilt fabrics were unheard of. I used indigo print fabrics from the African marketplaces. When I saw Upton's quilts in [the magazine] I was profoundly moved. There was such strength in her quilts that were non-traditional back in the early '70's. That was exciting to me and informed my resolve to make my own designs."[50] This sort of testimony is similar to that of others concerning newspapers and magazines of the 1970s and early 1980s illustrating the quilt art of Rhoda Cohen, Nancy Crow, Gayle Fraas and Duncan Slade, Nancy Halpern, Michael James, Carolyn Mazloomi, Ruth McDowell, Yvonne Porcella, and other artists. Reviews of exhibitions, discussed in Chapter Two, were especially influential.

Quilter's Newsletter in 1971 began publishing avant-garde quilts, with a black-and-white image of Mary Borkowski's *Outer Space* created for the Ohio Historical Society.[51] In 1974 the magazine announced that Diane Leone had won Best of Show in an art exhibition at the Triton Museum in Santa Clara, California. Leone was quoted as saying: "When a revived home art competing with all the other media gets that kind of recognition, you have to admit that quiltmaking is definitely an art form."[52] During the mid-1970s, with the excitement of the bicentennial, *QNM* set up a Quiltmobile that the editor's husband drove around parts of the country, showing old and new quilts and looking for interesting quilts to publish in the magazine. By then the publication was publishing works in color, illustrating such brilliant fiber art as the silk-screened quilts of Cindy Miracle, at that time a graduate student in art at Claremont College.[53] Increasingly, *QNM* added articles on surface design processes, with the cover of an issue in 1976 featuring Jeanie Spears's batik quilt *Red, White, and Woman*, a tribute to both the bicentennial and International Woman's Year (1975).[54] In the following year, art-related issues were emphasized as Michael James began a series of articles "designed to help you in planning and using color in your quilts." The illustrations included contemporary quilts by Radka Donnell and Nancy Halpern.[55]

Craft Horizons began publication in 1941, with the title changed to *American Craft* in 1979.[56] This journal was significant, partly because it included announcements and reviews of most of the major quilt shows, regional as well as national, at the very beginning of the studio quilt movement (see Chapter Two). New materials, techniques, and processes were reported in its pages,[57] along with essays and transcribed panel discussions and interviews dealing with pedagogical and theoretical aspects of craft (see Chapter Four). Contemporary quilt art was featured in several nearly full-page images, such as a white-and-beige work by Rubynelle Counts,[58] an abstract quilted banner by Canadian artist Caroline Wickham,[59] and a conceptual quilt by Jody Klein.[60] Trude Guermonprez, an influential weaver, had a political piece (in color) on the cover of the June 1976 *Craft Horizons*.[61] Having trained in Europe at schools that practiced Bauhaus aesthetics, in 1947 she taught Anni Albers's classes at Black Mountain College. Later she taught at the California School of Fine Arts (San Francisco), and then at the California College of Arts and Crafts (Oakland),[62] continuing the Bauhaus influence. Numerous fiber artists, some of whom became quilt artists, took her workshops.[63]

Even though the images were in black and white, the studio quilts, quilted objects, collaged fabric, and tapestries and other wall hangings illustrated in the "Exhibitions" section of *American Craft* were inspirational. The 1980 issue alone featured work by Nancy Crow and

Marie Lyman,[64] Lucas Samaras and Patricia Malarcher,[65] Jody Klein and Risë Nagin,[66] and Helen Bitar (in color) and Tafi Brown (who won an award with her quilt *Rockingham Raising V*).[67] That same issue included a large image of one of Anne Kingsbury's cape-like quilted wall hangings.[68] Thus artists were exposed to the vital new medium of studio quilts, and in an open environment in which the work of Marie Lyman was mentioned on the same page as the art of Bruce Nauman, Peter Reginato, and Robert Rauschenberg (who "demonstrated that he has opened up many new territories hitherto taboo in sculpture," with materials that included string, lace, and "chintzy cloth").[69]

Fiberarts Magazine was first published in 1975, with antique quilts described as art fairly early, in the May/June 1976 issue.[70] Initially *Fiberarts* focused on weaving and other textiles,[71] but occasionally offered profiles of artists working in the quilt medium, often described as "wall hangings" or "fabric constructions." One example is the work of Virginia Jacobs, for which both terms were used: "She uses the skills of hand and machine sewing, quilting and appliqué, in conventional and inventive ways, creating new techniques as needed to carry out her designs."[72] The highly ornamental and personal nature of these designs, handsomely illustrated, suggested new avenues to those working in the quilt medium. By the end of the 1970s, *Fiberarts* was featuring articles on workshops and schools with instruction in fiber art and textile design, such as the San Francisco School of Fabric Art.

Workshops, Classes, and Lectures

In the artists' surveys conducted for the present book, the workshops and lectures of Jean Ray Laury during the 1970s were praised more often than those of any other teacher, not only for the practical information they contained, but also for her sense of humor, which kept the presentations interesting. Caryl Bryer Fallert happened upon a lecture by Laury in 1982. Having run out of thread for the quilt project she had brought with her on a trip, Fallert went to a local fabric shop and heard about a lecture that evening titled "Quilting or the Breakfast Dishes"[73] sponsored by the local quilting guild. Her reaction to the lecture was a typical Laury revelation, the room being filled with enthusiastic, laughing women and the speaker her usual witty and articulate self—and doubly impressive because she had an M.A. in art from Stanford. Fallert began designing her first original quilt as soon as she returned home.

Guilds of quilt artists as such had not yet formed before the 1980s.[74] While a multitude of traditional, fairly large quilt guilds peppered the country by the 1970s, quilt artists[75]—who did not yet use that appellation—gathered in smaller, more informal groups. Numerous organized groups focused on "stitchery" and textiles, which sometimes included original quilted work, and whose guest lecturers and workshop directors shared technical and design information that could be applied to quilts.

During the 1960s, The Textile Arts Guild (Athens, Ohio), for example, numbered future quilt artist Virginia Randles among its members;[76] at that time she was concentrating on weaving. Joan Schulze was a member of the Peninsula Stitchery Guild[77] as of the latter 1960s, one of the first groups of its kind in the United States, and which often had workshops and critiques. In the early 1970s, Schulze took a motivating weeklong workshop in San Francisco

with the British needlework expert Constance Howard, who became her mentor. The workshop was very open-ended, as students experimented with several techniques, especially variations of embroidery. Schulze recalls that she was struggling to use imagery and words in the mid-1970s, finding appliqué in embroidery an interesting way to do that. B.J. Adams also benefited from her contact with Constance Howard. Joy Saville happened to attend meetings of the Peninsula Stitchery Guild in 1975 while on sabbatical in the Bay Area, with the classes taught by Evie Landes very helpful for her work at the time. Later in the 1970s, Saville benefited from guild lectures by Walter Nottingham.

Non-sewing workshops in which students learned new techniques and processes also contributed to the studio quilt movement. The American Craft Council sponsored several of these workshops.[78] Tafi Brown took part in a 1973 American Craft Council photography workshop, about which she says: "What I learned there meshed with my values and lifestyle and with what was available to me … at that time with a synergy that propelled me into my art quilt career. The workshop and the resulting influence on me were totally unplanned and unexpected."[79] This experience led to Brown's serendipitous creation of cyanotype studio quilts, a medium in which she has excelled for more than three decades [Fig. 10].

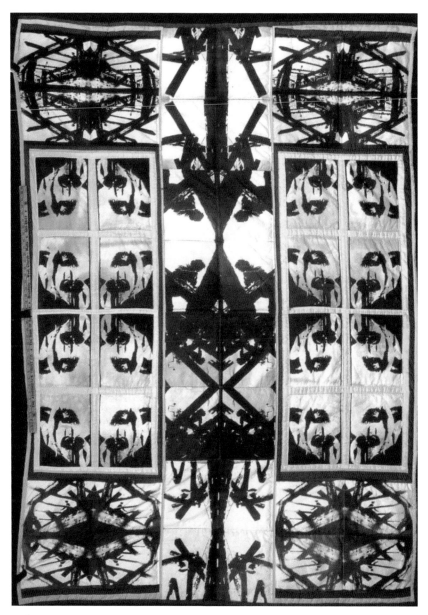

Fig. 10. Tafi Brown. *The American Wing VIII* (1976, 86 x 59 in.). From the artist's first cyanotype quilt series, in which she experimented with symmetry, pattern, reversals, and visual ambiguity. Because the fabric is a blend instead of 100% cotton, the blues are less intense than in Brown's later work.

Ed Larson contributed a non-sewing aspect to the pictorial quilt workshops that he taught during the 1970s from Maine to California. The images were very self-referential, "like W.P.A. projects,"[80] with Larson sketching the imagery that each student wished to incorporate into a quilt. He then taped pieces of brown paper together to reproduce the images to scale, so that the students could have patterns for cutting out pieces of fabric. These narrative projects often were quite personal. Michael James taught his workshop students to train their eyes, at the same time giving practical advice about streamlining the fabric-piecing process, with the result that several of today's quilt artists credit James's classes and books as formative influences on their careers. Linda MacDonald, for example, recalls that his first book "was invaluable because he showed how to stack all the pinned pieces up and sew them in long 'flags' through the showing machine [Fig. 11]. His work was important too because it was contemporary…."[81] James taught quiltmaking throughout southeastern New England during the mid-1970s, helping to make that area of the United States a nexus of quilt art, albeit on a smaller scale than that of Ohio, or of the hotbed of fiber art that included studio quilts in the Bay Area.[82]

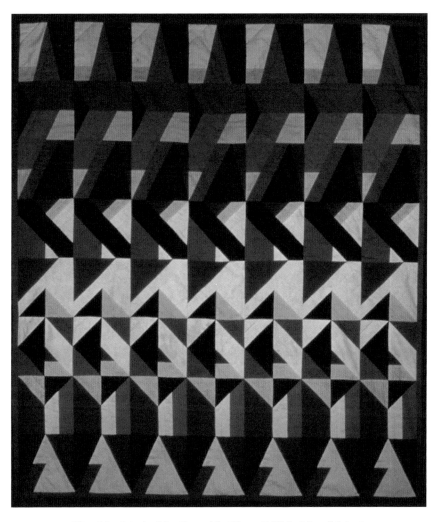

Fig. 11. Linda MacDonald. *Blues* (1976, 90 x 80 in.).

"By 1980 a substantial group of professional quilt lecturers and workshop leaders was available to the many quilt guilds seeking programs for their monthly meetings or for larger symposiums and conferences. Jeff Gutcheon taught his 'diamond patchwork' concept at the West Coast Quilter's Conference in Spokane, Washington, and Chris Edmonds was teaching pictorial appliqué classes. Jinny Beyer's medallion classes were extremely popular, and Yvonne Porcella's workshops based on her new book *Pieced Clothing* were very well received, especially after Houston's 2nd Quilt Market debuted the Concord/Fairfield Processing Fashion Show [an event that was repeated for many years]."[83] In addition, a few new programs were founded that focused exclusively on textiles, notably the Fiberworks Center for the Textile Arts in Berkeley, California (1973-1987).

Other Avenues

This chapter ends with anecdotal accounts from several individuals whose early quilt art derived from none of the above influences, exemplifying the diverse origins of contemporary quilt art in this country. These artists are among those who bypassed traditional quiltmaking lessons entirely.

Susan Shie's mother, a Mennonite, took her when she was a child to quilting bees at her church. But she never learned to quilt there. She purchased a how-to patchwork book when she was a teenager, but never used it. Instead, her first quilt-like object—begun when she was pregnant at the age of nineteen—was meant to be an abstract quilt for the baby. Shie "decided to start by cutting out one wild paisley shape freehand," then built the surface, shape by shape, from many different bold prints—a very painterly way to proceed.[84] The batting was polyester and the quilt was tied. But after numerous washings the quilt pulled apart because Shie had stitched the top together with rather unstable zigzag stitches, with no other reinforcement. While her concept was certainly original, the execution was less than perfect. But she learned from her mistake (and wishes today that she had a photograph of that quilt).

Jean Ray Laury grew up in the Midwest during the Great Depression and was familiar with quilts, but had never liked following other people's instructions so never learned to quilt while she was young.[85] She was, however, intrigued by anything handmade, and remembers her father cutting out aluminum templates for her mother's quilt patterns.[86] During the 1950s, as part of the project for the M.A. degree at Stanford, Laury decided to make a quilt, fulfilling the requirement for an object in traditional mode but contemporary in expression (see fig. 5). Although she had been working previously in watercolor, this experience with fabric captivated Laury, and she has been working in the quilt medium ever since.

Katherine Westphal was a teacher and textile designer during the 1950s, but stopped designing for industry in 1958 because her agent went out of business, shipping back to her all the swatches of cotton batiste on which Westphal had created her designs. In the early 1960s, she got the idea of sewing them together like patchwork, with her first effort at quiltmaking selected by Jack Lenor Larsen[87] for the Milan Triennale of Design, for which he was organizing the United States component (see fig. 40).[88] Although she had no immediate results from exhibiting in Italy, Westphal continued to make quilts with her vat-dyed designs, incorporating

"the expressive range of the painter's palette."[89] She says that she "really got hooked on doing patchwork quilts out of hand-printed textiles." Still active today, Westphal never uses any sort of patterns, but rather builds her surfaces intuitively, in collage fashion.

In 1973 Arturo Alonzo Sandoval received his first grant from the National Endowment for the Arts (a Craft Fellowship), using some of the funding to purchase a sewing machine. He explains: "... my first quilts were a self-taught experience by learning how to use the sewing machine to accomplish making the quilts in my grant."[90] The focus of this first quilt project, *Sky Wall*, was the transitional interior layer consisting of millinery netting. The work could be viewed from both sides: "The effect was a glorious front side of color and reflection, while the back side was the darker, stormy side."[91] Erotic imagery (the artist in various nude poses) was printed in blue ink on transparent vinyl and collaged into cloud-like shapes. "The idea was to hide the imagery by merging it with rose-patterned fabric so that audiences would have to look and try to find my body."[92]

Michael Cummings came to quiltmaking as a painter, but he wanted to work in fabric. Living in New York, he took advantage of the quilts on view at the Museum of Contemporary Crafts[93] and the Museum of American Folk Art,[94] studying their structure and stitching. Paul Smith, director of the Crafts museum, took Cummings under his wing and became an important mentor: "Paul Smith was very kind and perfectly serious looking at my crude quilt attempts. He critiqued my work in gentle terms...."[95] Several of the influential exhibitions viewed by Cummings and his contemporaries are discussed in Chapter Two.

5 The Internet did not exist for general users. It was not until 1991 that a user-friendly system was developed for the World Wide Web.

6 Charles Counts and his wife Rubynelle Counts made sure to credit the Rising Fawn Quilters for their work, and Ed Larson credited his quilters by having them embroider their names along with his on each quilt. In my phone interview with Larson in March of 2008, he asked me to mention that two of his regular quilters were Wanie Thomas and Carolyn Whelan.

7 An interesting sidelight in these publications is the gendering of new quilt patterns, such as "Out of This World Quilt for the Little [male] Astronaut's Room," a simple spool pattern, and "Quilt for the Little Princess," a "perky appliquéd flower quilt." These patterns appeared in *15 Quilts for Today's Living* (n.p.: Graphic Enterprises, 1968), pp. 26-27 and 28-29, respectively.

8 Ruby Short McKim, *One Hundred and One Patchwork Patterns* (New York: Dover Publications, 1962).

9 Marguerite Ickis, *The Standard Book of Quilt Making and Collecting* (New York: Dover Publications, 1972).

10 Donna Renshaw, *Quilting, A Revived Art: Cultivate the Art of Making Something with Your Own Hands* (Los Altos, CA: the author [c. 1975]. This was a modest production, typewritten with black-and-white illustrations, covered in a paper wrapper. Its price was $3. Until 1974, Renshaw owned The Quilting Bee, a store in Los Altos. http://www.aboutus. QuiltingBee.com (May 19, 2008).

11 Renshaw, op. cit., p. [i].

12 Alyson Smith Gonsalves, ed., *Quilting and Patchwork* (Lane Magazine and Book Company: Menlo Park, California, 1973). Donna Renshaw was an advisor for this publication.

13 Mazloomi still treasures her copy of *Quilting and Patchwork*: "The book is like a dear old friend! Its pages well worn, it's enshrined in a special place in my studio" (e-mail to the author, March 17, 2008).

14 Quilt seams should measure no wider than ¼ inch, unless the artist is purposefully manipulating the seams for a special effect. Clothing seams are usually 5/8 inch.

15 Judy Brittain, ed., *Vogue Guide to Patchwork and Quilting* (New York: Galahad Books, 1973).

16 The 1960s and 1970s perpetuated the assumption, which we now know to be false, that all antique quilts were made from scraps of fabric.

17 *The Progressive Farmer* was the only magazine seen by most of the quiltmakers living near Gee's Bend, Alabama, during the 19670s and 1970s. This fact is based on an interview with Tinnie Pettway and her sister Minnie Pettway that took place in Boykin, Alabama, on January 15, 2008. I am very grateful to them, and to Rennie Miller, for their generosity in sharing information about quilting in their African-American community, and about the original Freedom Quilting Bee.

18 Gross was one of the organizers of the American Quilt Study Group in 1980. Her collection of quilts and other items pertaining to twentieth-century quilts was recently acquired by the Center for American History at the University of Texas, Austin.

19 The name was changed as of the July 1974 issue.

20 In the mid-1970s, this author taught a traditional quiltmaking workshop in Champaign-Urbana, Illinois.

21 By the early 1980s, quilt artists who lectured and taught in workshops were traveling throughout much of the United States.

22 Now the Oregon College of Arts and Crafts.

23 Marie Lyman was assistant head of the Fibers/Textiles Department from 1978-1980. She also taught at the University of Oregon, Eugene, in the spring of 1978, and gave workshops in Seattle in 1979. This information was provided in Lyman's CV mailed to me by her husband, William McLaughlin, in March of 2008. I am grateful to Mr. McLaughlin for generously sharing his deceased wife's images, documents, and publications. (Readers should note that as of 1992, Lyman began calling herself Nyx Philomela Lymann. She died on October 28, 2000.)

24 E-mail to the author, May 9, 2008.

25 Artist's typed survey, 2007.

26 See *Quilter's Newsletter*, April 1974 (vol. 5, no. 4), p. 4, announcing that the University of Pittsburgh "will offer a course in Needlework as a Social History of Women this fall. The course is being sponsored jointly by the Women Studies Program and the Fine Arts Department," taught by Rachel Maines.

27 Jinny Beyer, *Patchwork Patterns* (McLean, VA: EPM Publications, 1979).

28 Robert Shaw, *The Art Quilt* (n.p.: Hugh Lauter Levin Associates, 1997), p. 54.

29 Rita Reif, "Quilting Is No Longer Just Another Pastime," *New York Times* (April 25, 1972), accessed online in the newspaper's archives. The article discusses several women in-

volved with traditional quiltmaking, including two who were successfully marketing kits for crib quilts to New York department stores such as Altman's and Saks Fifth Avenue. Beth Gutcheon is pictured behind a fabric-covered worktable, with her pieced quilt *Crazy Ann* partially visible on the wall behind her (quilt identified by this author from the reproduction on p. 65 of Beth Gutcheon, *The Perfect Patchwork Primer*, 1973). This article was an appealing presentation of Gutcheon and her work, most likely prompting students to enroll in the quilting classes.

30 Exhibition catalogues are discussed in Chapter Two.

31 Elsa Brown, *Creative Quilting* (New York and London: Watson-Guptill Publications and Pitman Publishing, 1975), p. 33.

32 Ann-Sargent Wooster, *Quiltmaking: The Modern Approach to a Traditional Craft* (New York: Drake Publishers, 1972), p. x.

33 While she was teaching studio art at the Catholic University of America in Washington, D.C. Sonnemann was a formative influence on Martin Puryear, who was one of her students.

34 Thelma R. Newman, *Quilting, Patchwork, Appliqué, and Trapunto: Traditional Methods and Original Designs* (New York: Crown Publishers, 1974), p. (vii).

35 E-mail to the author, February 12, 2008.

36 Audrey Heard and Beverly Prior, *The Complete Guide to Quilting* (Des Moines: Creative Home Library (in association with Better Homes and Gardens, 1974), p. [8].

37 Michael James was an important influence simply because of his gender. Michael Cummings, for example, stated in an e-mail of January 22, 2002, "that Michael James and Faith Ringgold have been my role models for reaching my goal as a quilter. Michael because he was the only male with a high profile making art quilts. Faith because ... I have always enjoyed her creative spirit."

38 Beth Gutcheon, *The Perfect Patchwork Primer* (Baltimore: Penguin Books, 1973), p. 22. On pages 250-252, Gutcheon mentioned three large quilt cooperatives whose quilts were being marketed in urban retail stores: Mountain Artisans (West Virginia mountain women), Dakota Handicrafts (Sioux Native Americans and Caucasians), and the Martin Luther King Freedom Quilting Bee (African-American women near Gee's Bend, Alabama). Interestingly, she explained that while the first two groups were producing quilts designed by others, the members of the Freedom Quilting Bee "designed their own quilts instead of working with a professional, and the quality of the design was outstanding." But because much of the work evidently was offered on speculation, the group was not very successful. (Recently the Freedom Quilting Bee was revived, along with a new company, That's Sew Gee's Bend, with purchasers eagerly acquiring recent Gee's Bend original quilts. This author is happy to be among them.)

39 Michael James, *The Quiltmaker's Handbook* (Mountain View, CA: Leone Publications, 1993 reprint), p. 1.

40 Chatterton's comment about Colby's quilt is something of an understatements: "Sas Colby makes interesting use of printed and plain fabrics to create her designs" (p. 47).

41 Mariska Karasz, *Adventures in Stitches: A New Art of Embroidery* (New York: Funk & Wagnalls, 1949), p. 9.

42 David B. van Dommelen, *Decorative Wall Hangings: Art with Fabric* (New York: Funk & Wagnalls Company, Inc.,1962). The book includes an installation shot of the fabled *Invention with Thread II* 1961 exhibition at the Montclair (NJ) Art Museum on p. 107.

43 Jean Ray Laury, *Applique Stitchery* (New York: Van Nostrand Reinhold Company, 1966), p. 11.

44 Op. cit., p. 28.

45 Carolyn Vosburg Hall, *Stitched and Stuffed Art: Contemporary Designs for Quilts, Toys, Pillows, Soft Sculpture and Wall Hangings* (Garden City: Doubleday & Company, 1974).

46 Lisa Hammel, "Handcrafts: Show and Tell," *New York Times* (October 17, 1974), accessed online via the newspaper's Web site.

47 She had no idea how the editors planned to use the image of her quilt, but agreed to make it because this was the first time she knew of that the magazine had shown any interest in handicrafts. Typed note [n.d.] on Mylar envelope containing an offprint of the page, loaned to the author by Laury.

48 Autograph note [n.d.] on Post-it, on Mylar envelope containing an offprint of the article, lent to the author by Laury.

49 Twyla Dell, "A Heart To Heart Talk with Jean Ray Laury," *Quilt World* (September/October 1979), pp. 10-12.

50 E-mail to the author, March 16, 2008.

51 *Quilter's Newsletter* 1971 (nos. 21-22), p. 24. Unless noted otherwise, the art-related items were published in the "What's New—and News—in Quilting" column.

52 This is the first instance that I know of quiltmaking being referred to as a "revived home art." That terminology seems not to have been used subsequently.

53 *Quilter's Newsletter Magazine*, 1976, vol. 7 (no. 5), pp. 16-17.

54 *Quilter's Newsletter Magazine*, 1976, vol. 7 (no. 6), with pp. 23-25 giving instructions on how to make a batik quilt.

55 Michael James, "Color in Quilts," *Quilter's Newsletter Magazine*, 1977, vol. 8 (no. 3), pp. 16-17. First article in a three-part series.

56 American Craft Council Web site. http://www.craftcouncil.org/html/magazine/main.shtml.

57 *Craft Horizons* was a prime resource for Patricia Malarcher as she prepared her presentation on surface design in contemporary quilts of the 1960s and 1970s for a panel organized by me for the 2008 annual conference of the College Art Association. In that same session, Michael James spoke about the history of the movement, and I presented a paper on politics and contemporary quilt art from 1960 to 1980. The title of the session was *The Evolution of Contemporary Quilt Art*, a voice recording of which may be purchased in a CD set of two disks (CA08-043) from the College Art Association, http://www.collegeart.org.

58 *Craft Horizons* (June 1966), p. 81.

59 *Craft Horizons* (June 1974), p. 33.

60 *Craft Horizons* (February 1977), p. 29.

61 Joan Schulze was among the many students who benefited from her workshops.

62 Recently renamed the California College of the Arts.

63 Ed Rossbach, "Trude Guermonprez, 1910-1976" [obituary], *Craft Horizons* (August 1976), p. 10. Black Mountain College runs like a refrain through the fiber art of the 1960s and 1970s, with several artists having studied there, or having studied under teachers who were alumni.

64 Feb/March, p. 70.

65 Apr/May, p. 69.

66 June/July, p. 74.

67 Oct/Nov, p. 4 and 71, respectively.

68 Aug/Sept, p. 39.

69 *Craft Horizons* (August 1977), p. 65.

70 The quilts were from the collection of Mary Woodard, organizer of the Santa Fe Textile Workshops (pp. 8-9). The title of the magazine was changed in 2004 to *FiberARTS: Contemporary Textile Art and Craft*, with a searchable index for all issues available at http://www.fiberarts.com/indexes/default.asp.

71 The 1979 *Fiberarts Equipment Directory* had thirty pages of looms, eleven pages of spinning wheels, and not much else.

72 Amy Zaffarano Rowland, "Building on Experience: Virginia Jacobs' Fabric Constructions," *Fiberarts Magazine* (July/Aug 1980), pp. 39-43. Interestingly, Jacobs mentioned that she listened to music while she worked because it helped free her creativity. The same comment was made by most of the artists who responded to the survey concerning the present book.

73 This lecture was part of the quilt seminar at the Amherst Museum (Amherst, New York), an annual event since the mid-1970s.

74 In 1987 Nancy Crow and Linda Fowler organized Art Quilt Network in Ohio. This group inspired spin-off organizations, such as Art Quilt Network/New York.

75 The National Quilter's Association was established in 1969, but the American Quilter's Society was not founded until 1985. Both organizations focused on traditional quilters.

76 Pritchard, op. cit., p. 35.

77 Located in the San Francisco Bay area.

78 I would like to thank the staff of the ACC Library in New York City for their generous assistance during my research for this book, and for their help in providing visuals. (Sadly for me, the ACC has now relocated to Minneapolis.)

79 E-mail to the author, March 14, 2008. Tafi Brown also mentioned the importance for her early quilts of "one fabric store in Peterborough, NH (Joseph's Coat) that had wonderful and unusual fabrics. The employees were well educated, extremely creative, gifted and supportive with diverse backgrounds. (One of them had taken one of Nancy Crow's workshops way back in the early '70s.) I make this notation because of the visual stimulation, collegiality and support of this place and its employees." The present book does not attempt to analyze the effects of local fabric and quilt dealers on the development of contemporary quilt art between 1960 and the early 1980s. This is, however, a subject well worth investigating.

80 Phone interview of March 2008.

81 E-mail to the author, March 9, 2008.

82 For succinct information on textile art in and near San Francisco before 1960, see Jan Janeiro, "Before the '60s: The Early History of Bay Area Textiles," *Fiberarts Magazine* (Jan/Feb 1993), pp. 32-35.

83 Louise O. Townsend, "What Was New and News in Quilting 1969 through 1984," *Quilter's Newsletter Magazine*, Special 15th Anniversary Issue, 1984, p. 17.

84 E-mail to the author, March 9, 2008.

85 Like much of the information in the present book, most of the facts in this section were supplied by artists in surveys sent by the author between 2001 and 2008. For an in-depth interview conducted with Laury by Le Rowell in 2000, see http://www.centerforthequilt.org under the ongoing "Save our Stories" project. Many of the artists mentioned in this book have been interviewed for "S.O.S." ("Save Our Stories"). The "S.O.S." project includes traditional quilters as well as contemporary quilt artists.

86 E-mail to the author, September 19, 2002.

87 Larsen was a friend of Westphal's husband, basket artist Ed Rossbach.

88 That quilt was stolen when someone broke into the magazine office in New York City where the quilt was to be photographed, stealing the cameras and evidently using Westphal's quilt to wrap them. But she completed a second quilt that was exhibited instead.

89 Ursula Ilse-Neuman, curator of the exhibition *Art Quilts from the Collection of the Museum of Arts & Design* (2006, at the American Textile History Museum in Lowell, MA), which included Westphal's 1969 quilt *Tiepolo*. http://www.athm.org/exhibitions_artquilts.htm (March 31, 2006).

90 E-mail to the author, March 9, 2008.

91 Ibid.

92 E-mail to the author, May 10, 2008.

93 The American Craft Museum was founded in 1956 as the Museum of Contemporary Crafts; in 1986 it was renamed the American Craft Museum; and, in 2002, renamed once again as the Museum of Arts & Design. http://madmuseum.org/INFO/MuseumHistory.aspx.

94 The original emphasis of this museum when it was founded in 1961 was folk art of the eighteenth and nineteenth century from the northeastern United States, when its name was the Museum of Early American Folk Arts. In 1966 the name was changed to the Museum of American Folk Art, then in 2001 to the American Folk Art Museum, with a more global focus. http://www.ny.com/museums/museum.of.american.folk.art.html.

95 E-mail to the author, January 22, 2002.

CHAPTER 2:
QUILTS AND OTHER ART ON VIEW

Exhibitions of antique and contemporary quilts influenced the work of quilt artists, and, in some cases, their decision to venture into the quilt medium. Occasionally the exhibition experience was enhanced because the quilts were discussed with colleagues as they were viewed. This chapter considers exhibitions read about or seen by quilt artists, as well as exhibitions in which their art was shown, which in turn influenced the next wave of those creating quilt art after the early 1980s.[96]

EXHIBITIONS OF OTHER FIBER AND TEXTILE ART

Several exhibitions which did not feature quilts per se helped to set the scene for contemporary quilt art, particularly with the acceptance of fiber as a material in shows mounted by major museums. The most important were those that traveled, and those for which catalogues or related books were produced because exhibition tours and publications extended the life of each exhibition far beyond its original scope.

The Museum of Modern Art

In the fall of 1961, the Museum of Modern Art in New York opened *The Art of Assemblage*, accompanied by a 176-page catalogue that included three essays on collage and assemblage.[97] These texts were written by William C. Seitz, Associate Curator in the Department of Painting and Sculpture Exhibitions at the museum (see Chapter Four). The exhibition traveled to the Dallas Museum for Contemporary Arts and the San Francisco Museum of Art.

The works on display incorporating fiber included Arthur Dove's *Grandmother*, 1925 (shingles, needlepoint, paper, pressed flowers); several collages by Kurt Schwitters with textiles and buttons; and, Alberto Burri's *Number 5*, 1953 (glue and tempera on burlap, with visible stitching and tears). The show encouraged artists to experiment in both technique and material. As Seitz stated in his foreword, the works in this exhibition were "predominantly *assembled* rather than painted, drawn, modeled, or carved," and consisted "entirely, or in part … [of] preformed natural or manufactured materials, objects, or fragments not intended as art materials." Thus the door was slightly open for quilt art to be considered seriously, but it would not be wide open for another two decades.

New York designer Jack Lenor Larsen was a pivotal force internationally for exhibitions of fabric and textile art.[98] He organized *Wall Hangings* in 1969 for the Museum of Modern Art (New York), presenting works spotlighting "a new art form that weren't traditional flat tapestries, nor were they necessarily sculptural and dimensional, but they were new and bold."[99] This collection, installed on the ground floor, had excellent public exposure. Jane Burch Cochran and Patricia Malarcher are among the quilt artists who consider this exhibition as a memorable experience. Analogies can be seen between "developments in weaving [that] have caused us to revise our concepts of this craft and to view the work within the context of twentieth-century art"[100] and shifts in visual culture that caused quilts to be viewed by some as contemporary art by the early 1970s. Not the least of these was the extensive involvement of women as artists in both weaving and quiltmaking. Because the *Wall Hangings* catalogue was rather brief, Larsen and the MoMA curator with whom he was working, Mildred Constantine, produced a book in 1973 titled *Beyond Craft: The Art Fabric* "that caused a considerable stir and led to a second show.[101] The show opened at the San Francisco Museum of Art [in 1981]"[102] *Beyond Craft: The Art Fabric* celebrated the "new freedom" being experienced by fiber artists—"the freedom to choose an aesthetic over a utilitarian need."[103] The same could be said of contemporary quilt art.

The Museum of Contemporary Crafts

The Museum of Contemporary Crafts in New York mounted several influential exhibitions under the aegis of the new director, Paul Smith. In 1963 the museum opened an exhibition of recent tapestries titled *Woven Forms*. The forty-five works on display were by Alice Adams, Sheila Hicks, Lenore Tawney, Dorian Zachai, and Claire Zeisler. Rose Slivka, the editor of *Craft Horizons*, reviewed the show with obvious enthusiasm. She praised the sculptural presence of the tapestries, singling out collage as a major influence: "In our milieu of artistic experimentation in which all materials and techniques are being challenged and reinvestigated, these tapestry makers have found their contemporary reality in the pure object ... the same spirit that infuses the struggle of painting to leave the flat canvas...."[104]

Fabric Collage, mounted in the spring of 1965 at the Museum of Contemporary Crafts, had three sections: contemporary hangings, American quilts (all from the nineteenth century), and appliqués (i.e., molas, in reverse appliqué) from the San Blas natives, along with a catalogue containing black-and-white illustrations.[105] The contemporary hangings (including quilt-like objects) were by Lillian Elliott, Alma Lesch, Elizabeth Jennerjahn, Marilyn Pappas, and Marie Kelly. All five works by Lesch and three by Pappas incorporated actual items of clothing, materials that later would appear in quilt art by other artists. In his introduction, Smith stated: "The expressive possibilities of fabric—the seemingly endless variety of textures, colors, and tactile sensations—that we see in contemporary collage parallel the innovations in contemporary art, particularly assemblage."[106]

Young Americans 1969 was the first such competition since 1962 to be juried by the American Craft Council. One of the jurors was Peter Selz, director of the University Art Museum in Berkeley. This exhibition premiered in Albuquerque at the University of New

Mexico Art Gallery, then traveled to the Museum of Contemporary Crafts. As mentioned by the reviewer for *Crafts Horizons*, the show was strong in textiles, with 52 of the 207 works "executed in every imaginable technique."[107]

In 1973, the Museum of Contemporary Crafts mounted *Sewn, Stitched & Stuffed*, with works created after 1969. Sandra Zimmerman, owner of the Van Bovenkamp Gallerie in New York City, curated the exhibition.[108] Artists included Lenore Davis and Joan Lintault [Fig. 12], who became known during the early 1970s for their quilts, and Patricia Oleszko, whose use of zany humor in fiber art was notably original at the time. Quilting was among the techniques listed for several of the works.[109]

Fig. 12. M. Joan Lintault. Untitled (1969, 81 x 44 in.). When the artist worked in ceramics, most of her work was white. The sculptural form of ceramics influenced her treatment of the surface of this transitional quilt.

In her introduction to the catalogue, Zimmerman emphasized the mixed-media nature of the art: "Several techniques are often combined in the same work. Quilting, trapunto, and other types of sectional padding are used with great innovation. Embroidery, appliqué, and stitchery are used as decoration and also become an integral part of the form and design of the work. Processes not usually associated with fabric, such as etching, photo silkscreen, watercolors, and photo blueprint on cloth are used here to enrich and expand the artist's statement." Her championing of this sort of work was prescient in that much of the quilt art of the latter 1970s and early 1980s featured mixed media, with several influential artists working in surface design processes and techniques (see Chapter Four).

Objects : USA

The monumental exhibition *Objects : USA* opened in 1969 at the Smithsonian and toured for three years in the United States and Europe, its three hundred objects viewed by many thousands. The exhibition was organized by Lee Nordness, who began his career in New York City in Nordness Gallery, founded 1958, initially specializing in contemporary painters and sculptors even though he collected the work of "craftsmen."[110] He began his gallery business by organizing *Art : USA*, an exhibition of emerging and unknown painters and sculptors. The following year, for the next *Art : USA*, he asked Paul Smith to select craft objects for the show. With his seamless appreciation of art created in any medium, Nordness became a champion of craft as art, encouraging the S. C. Johnson & Son Company (Johnson's Wax) to patronize craft artists in the United States. This corporation sponsored the *Objects : USA* tour and its fully illustrated catalogue. Organized by medium, the catalogue contains 76 pages concerning fiber art, with twelve full-page color plates among the numerous illustrations, one of which reproduces a detail from Katherine Westphal's 1967 pieced quilt *A Square Is a Many Splendored Thing*.[111] Works by Alma Lesch (*Like Father, Like Son*, p. 316) and Marilyn Pappas (*Opera Coat*, p. 321), both utilizing found objects, are also illustrated in color. Among the influences on her work, Pappas mentioned "Rauschenberg assemblages, Schwitters collages, and Matisse's use of space."[112] The exhibition was famously reviewed by John Ashbery, a poet and friend of Andy Warhol, who at the time was serving on the editorial board of *ARTnews*. His review was a virtual manifesto for craft artists: "One hears much of ferment in the world of crafts, that craftsmen want recognition as full-fledged artists Somebody should tell craftsmen right away that they *are* artists so they can stop worrying and we can go on enjoying their work as art."[113] Jane Burch Cochran recalls the impact of *Objects : USA* on her art.

Joan Schulze saw the 1970 *Objects : USA* exhibition on the West Coast, at about the same time that she began exhibiting her own stitched work (small landscapes and embroidered pendants) in Bay Area galleries. She decided in 1970 to identify herself as an artist. While there was no major museum exhibition of contemporary quilt art in northern California during the early 1970s, several artists interviewed for the present book recall seeing important fiber exhibitions. Artists whose work made an impression included Olga de Amaral and Barbara Shawcroft, both of them working in relatively large formats.

Other Exhibitions

Solo shows in museums and galleries of works by other artists working in textiles and fiber, such as Magdalena Abakanowitz and Joyce Kozloff, were also inspiring to young artists beginning to explore these media. Kozloff credits a "wide range of sources," suggesting that quilt artists "may have been looking at the same sources" because when an artist is working on a grid, "certain kinds of arrangements occur."[114] Her 1977 installation *An Interior Decorated*, featuring large screen-printed silk banners, was seen in 1978 at a gallery in New York, then traveled to three other venues, including the Renwick in Washington, D.C.

Several individual quilt artists were influenced by exhibitions or events that were mentioned only once or twice in the surveys for the present book, but those influences were so meaningful that at least a few should be noted. These examples serve as touchstones for the diversity of visual stimuli that contributed to the development of contemporary quilt art.

Yvonne Porcella was amazed by a 1974 exhibition of embellished denim objects at the M.H. de Young Memorial Museum in San Francisco, and she helped organize *Art To Wear* at the Oakland Museum that same year. One of Porcella's works exhibited in 1979, a quilted kimono, is Judith Content's earliest memory of quilted surfaces as art [Fig. 13]. Content also recalls the stirring presence of textiles in Judy Chicago's *Dinner Party*, first exhibited in San Francisco in 1979.

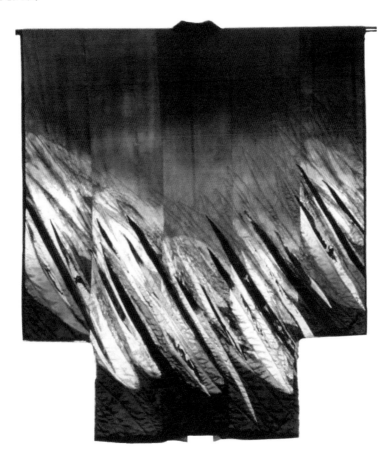

Fig. 13. Judith Content. *Sweltering Sky Kimono* (1982, 61 x 52 in.). Collection of the Fine Arts Museums of San Francisco.

For Linda MacDonald, that installation was "an incredible experience. She [Chicago] had combined women's history [and] art with the minor 'feminine arts' of needlework and plate painting." (See Chapter Three.) *Fabric in Art*, an exhibition in 1980 at the College at Old Westbury organized by Harriet Senie, and which subsequently toured, featured the work of several members of the Pattern and Decoration movement. The show included textiles by Sam

Gilliam, Robert Kushner, Robert Rauschenberg, and Miriam Schapiro.[115] Jeanne Williamson's most memorable pre-1980 "exhibition" involving textiles was a ballet staged in Philadelphia designed by Alexander Calder: "The dancers wore dresses in his colors and patterns, and they had HUGE props from his mobile shapes they danced with. It was a religious experience!"

The direction of Marie Lyman's work began to change course in 1974 when she first encountered the *kesa* (Buddhist priest's traditional pieced robe) in an exhibition at the Portland Art Museum [Fig. 14].[116] She subsequently traveled and studied in Japan, developing an affinity for Japanese culture, particularly "attention to detail and sensitivity to color."[117] In turn, Lyman's own textile art exhibited at the University of Oregon in 1978 made an impression on Wendy Huhn.

Fig. 14. Marie Lyman. *Robe #3* (late 1970s, 28 x 42 in.).

Finally, before we turn to exhibitions displaying quilts per se, mention should be made of the 1964 Venice Biennale, dominated by artists from the United States with an exuberant pop art mentality. Robert Rauschenberg's mixed media combines won the grand prize, and the French Pavilion exhibited three fairly large works that today would be described as quilt art. These pieces would not have been known to most American artists, except for the fact that *Craft Horizons* published an overall image and large detail in the Biennale review, which stated: "one of the highpoints of the [Biennale] is a group of three appliqué and stitchery wall hangings by Roger Bissière of France... [who] uses whatever comes to hand—hop sacking, fish net, old carpets, jersey, printed plush—and collages these elements into an amazingly stable whole."[118] The imagery in "The Goat" (the work illustrated) recalls that of Picasso and Miró, but with the textured embellishment of a Victorian crazy quilt.

EXHIBITIONS OF QUILTS

The Museum of Contemporary Crafts

In 1961 Frances Robinson had one of the earliest solo shows of contemporary quilt art within the two decades covered by the present book. Her machine-embroidered quilts in the Members Gallery of the Museum of Contemporary Crafts were reviewed in *Craft Horizons* by Alice Adams: "Experience in the graphic arts was in evidence where the closeness of the stitches to one another suggested a line etched or engraved into the cloth. The relentless quality of this machine-stitched line and the flickering of the stitches over the surface was used to create luminosity and spatial depth."[119] Robinson's highly expressionistic quilt *Sunflowers* was illustrated in the review.

Examples of Other Exhibitions in the 1960s

The 1960s saw various small exhibitions of contemporary quilt art across the country, often with the quilts shown alongside other types of craft objects, or in faculty shows. The First Annual Western Craft Competition, exhibited at the Seattle Center in 1964, featured quilt art by Helen Bitar and Katherine Westphal. The Northeast regional section of *Craftsmen USA '66* shown at the Delaware Art Center and the Museum of Contemporary Crafts included an appliqué quilt by Sophia Adler. A few solo shows featured quilt work, such as Nik Krevitsky's 1966 exhibition in San Francisco at Temple Emanu-El which displayed twenty padded, quilted works titled *Paintings in Thread*, "with the imposition of opaque and transparent yarn structures making use of both surface and pictorial space in the best way."[120]

The Whitney Museum

In 1971, the Whitney Museum of American Art in New York mounted the first comprehensive exhibition of quilts to be seen in a major museum whose mission focused on contemporary art, with an emphasis not on the historicity of the works, but rather on quilts as visual objects: the now-famous *Abstract Design in American Quilts*. Joan Lintault says, "it was a wonderful experience to see such an exhibition at a prestigious museum." The sixty quilts in the show were from the collection of Gail van der Hoof and Jonathan Holstein, both of whom had backgrounds in contemporary art and who developed an appreciation of quilts during the latter 1960s. In 1973 and 1974, twenty-one venues in the United States exhibited parts of the collection that had been shown at the Whitney plus thirty additional quilts (45 in each of the two parts), in a tour directed by the Smithsonian Institution Traveling Exhibition Service (SITES).[121] Some of the quilts also traveled to Europe; Sylvia Einstein saw them in Switzerland [Fig. 15]. Numerous artists interviewed for the present book saw one or more of the installations.

Fig. 15. Sylvia H. Einstein. *Pattern of Least Regret* (1978, 65 x 45 in.). The "hearts" are constructed from the artist's husband's mended socks, and her maiden name appears throughout the quilt on laundry labeling strips.

In his 1971 catalogue essay, Holstein stated: "Quiltmakers did in effect paint with fabrics, laying on colors and textures, borrowing, and trading here and there or purchasing particular colors or patterns of materials they needed to complete their designs."[122] For their collection, Van der Hoof and Holstein made a point of purchasing quilts that worked for them as paintings, "creations in which the maker had posed and successfully solved interesting aesthetic propositions."[123] The 1971 exhibition caused young people working in diverse media to value the quilt as an art form. Paula Nadelstern and Robin Schwalb were among them. Michael Cummings not only viewed the quilts as art, but also began considering Rothko paintings within a similar aesthetic framework. He recalls, " There was an historic moment when the definition of craft and art were put aside." Beth Gutcheon views the Whitney show as "most important to me." Reviews of *Abstract Design in American Quilts* revealed a deep appreciation of quilts as art, evidently to the surprise of some of the reviewers.

1971–1975

The first few years of the 1970s saw sporadic, local exhibitions of contemporary quilt art in several parts of the country, such as those organized by Joyce Gross in Mill Valley, California.[124] Then, in 1975, three exciting museum and gallery shows were mounted in the Northeast.

Fig. 16. Radka Donnell. *Das Grosse T* (1974, 100 x 84 in.). "The Big T." The artist based the dimensions of this quilt on the human body, expanding a single block to monumental proportions.

Susan Hoffman and Molly Upton exhibited quilts together in the Kornblee Gallery (New York) in *Quilted Tapestries*, showing pairs of quilts inspired by various themes; Hoffman, Upton, and Radka Donnell had a group show of mostly abstract quilts at the Carpenter Center for the Arts, Harvard University [Fig. 16]; and, The DeCordova Museum in Lincoln, Massachusetts, organized *Bed and Board*, exhibiting original contemporary quilts along with contemporary woodwork.[125] The quilt artists in *Bed and Board* included Elsa Brown, Sas Colby, Lenore Davis, Beth and Jeffrey Gutcheon, and Michael James (who at the time was teaching quiltmaking at the DeCordova Museum). Nancy Halpern describes the exhibition: "More selective and determinedly non-traditional, this work was elegantly set-off by white museum walls and proper lighting."[126]

1976-1979

Preparations for the U.S. bicentennial of 1976 prompted several significant quilt-related events, including *Quilts '76*, organized by the Boston Center for the Arts (at the mammoth Cyclorama building), the Great Quilt Contest with its subsequent touring exhibition, and *The New American Quilt* exhibited in New York at the Museum of Contemporary Crafts in 1976.[127]

The Boston show, which was not juried, had 173 quilts, mixing traditional and contemporary work. It was a glorious hodgepodge, seen by thousands of visitors. Sylvia Einstein's first quilt, executed in appliqué, was in the exhibition. Nancy Halpern, who had a quilt in the show, recalls that the event was organized into "crazy categories."[128] Discussing both *Bed and Board* and the Boston exhibition, Halpern has remarked, "The most impressive feature of *both* shows was undoubtedly the variety of quilts displayed. Design ideas had been gathered from every corner of the map and from individual consciousness, and the resulting quilts were intrepid and vital. Although there was concern for good workmanship also, these shows were less noteworthy as exhibitions of great stitching than as displays of great imagination."[129]

The Great Quilt Contest, sponsored by the U.S. Historical Society (a private organization) and the Museum of American Folk Art, was advertised via *Good Housekeeping*. The call for images resulted in some 10,000 entries, from which 51 quilts were selected, the "most outstanding"[130] examples from the United States plus the District of Columbia. The national winner, announced in 1978, was a quilt pieced by Jinny Beyer; this recognition catapulted her to a position of prominence among quilt artists. Nancy Erickson says that she first realized the possibilities of quilts as art after she saw this exhibition, a "wow" experience that prompted her to move from fabric sculpture to "flatties."

In *Erica Wilson's Quilts of America* (1979), the author documented quilts in the exhibition, adding works by several of the runners-up. Although some of the quilts are traditional in concept, the contestants having utilized templates in a pattern for piecing or appliqué, others are entirely original, such as several pictorial quilts and abstract compositions. Most of the illustrations are in color. The artists who made some of the strikingly original quilts include Teresa Barkley, Lisa Courtney, Chris Wolf Edmonds, Ed Larson, Martha Mood, Susan Murphy, Karee Scarsten, and Joan Schulze [Figs. 17 and 18].

Fig. 17. Teresa Barkley. *Denim Quilt* (1972, 94 x 77 in.). This was her first quilt that the artist considered successful, and it ignited her passion for collecting vintage textiles.

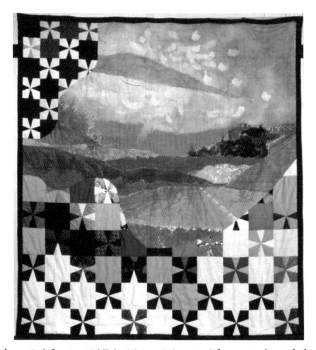

Fig. 18. Joan Schulze. *California* (1976, 104 x 96 in.). The artist's eighth quilt, in which the central landscape is batik made of whole cloth.

The New American Quilt exhibition (1976) was the first quilt show in a major museum to feature contemporary, non-traditional work exclusively, and the show traveled. Lisa Hammel's review for *The New York Times* informed readers across the country about this astonishing show, which featured thirty-eight quilts by twenty-four artists, including Teresa Barkley, Helen Bitar, Elsa Brown, Lenore Davis, Radka Donnell, Gayle Fraas and Duncan Slade, Susan Hoffman, Joan Lintault, Molly Upton, Wenda von Weise, and Katherine Westphal. Hammel described how quilt artists "have been stretching the limits of the folk idiom through new processes and new techniques, new images and new ideas, until they have come out at the other end with something totally individual—the quilt transcendent."[131] The *Craft Horizons* review presented readers with graphic evidence of the originality and significance of these quilts, with Westphal's luminous *Puzzle of the Floating World* reproduced in color on the cover of the journal [Fig. 19]. As the review made clear, "the new-directions quilters are having their day ... with a brilliant showing of contemporary quilts."[132] Several quilt artists interviewed for the present book were astonished by this exhibition, and others had quilts in the show.

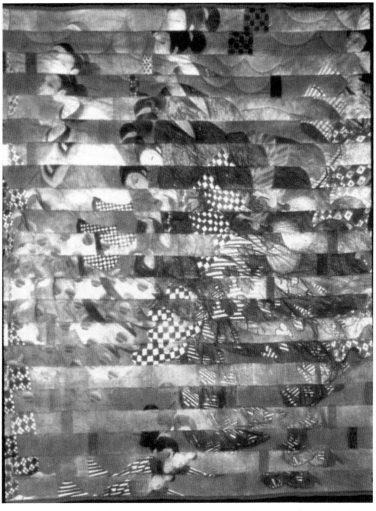

Fig. 19. Katherine Westphal. *Puzzle of the Floating World – No. 3* (1975, 83 x 69 in.).

Momentum for contemporary quilt art continued to build during the second half of the 1970s, prompted by the bicentennial quilt exhibitions (mostly of traditional work), craft and design competitions, workshops, new books and magazines, and easier processes for applying color and imagery to fabric. Art schools were beginning to recognize quilt art. In 1976, for example, three students at New York's Pratt Institute exhibited quilt art projects at the school. Kathleen Caraccio, Gertrude Sappin, and Deborah Hallam printed, painted, stamped, and stitched fabric works that were then completed by Amish quilters in Ohio.[133]

Penny McMorris organized *Ohio Patchwork 76*, "the point of confluence for Ohio artists already exploring quiltmaking as an art form in the 1970s."[134] Traditional quilts were shown along with more innovative works in this juried traveling show; the only requirement was that the quilts had to have been made in Ohio within the past three years. Original quilts by Nancy Crow, Françoise Barnes, Wenda von Weise, and Judi Warren Blaydon were included. Directors of art centers, galleries, and museums in Ohio had an early and enthusiastic appreciation of contemporary quilt art, partly due to the efforts of McMorris.

Also in 1976, the first event which can be considered, in retrospect, as a national quilt conference was held in Ithaca, New York, in conjunction with the Finger Lakes Bicentennial Quilt Exhibit. The presenters included Beth Gutcheon and Jean Ray Laury, who by that time were well know as a result of their books and workshops. Virginia Avery was among the many artists who either attended or heard about the events from others. She has referred to the conference as a "turning point for her career."[135] In Houston, Quilt Fair '76, the forerunner of the popular annual festival, was organized by Karey Bresenhan. The Houston festival first exhibited studio quilts in 1984.[136]

In 1977, Hofstra University's Emily Lowe Gallery (on Long island) exhibited twenty quilts by fourteen "contemporary craftsmen," more than half of whom were male. This show caught the attention of the press and was reviewed in *The New York Times* by David L. Shirey (who later became chair of the Fine Arts Department at the School of Visual Arts, New York). Like Holstein and van der Hoof, he preferred graphically abstract quilts, such as *Razzle Dazzle* by Michael James: "an extraordinary combination of poetic design and fresh color combinations (see fig. 2)."[137]

The American Craft Council sponsored a *Young Americans* exhibition in 1977, the previous such competition having been in 1969. *Fiber/Wood/Plastic/Leather*, the first series in this competition, opened at the Southeastern Center for Contemporary Art (Winston-Salem, North Carolina) in conjunction with the ACC'S annual conference. The show then toured for a year, including a stop in New York at the Museum of Contemporary Crafts. Glen Kaufman reviewed the *Fiber* component for Craft Horizons, remarking on the strong presence of quilts among the seventy-one works by fifty-eight artists: "The influence of the Museum of Contemporary Crafts' *'The New American Quilt'* exhibition and the exhibitions sponsored by the newly formed Surface Design Association seem evident."[138] The quilts and quilt-like pieces illustrated are by Jan Anderson, Deborah Kaufman, Joy Stocksdale (a kimono), and Susan Yowell.

Quilt National, 1979[139]

Although the fifty-six quilts in the first *Quilt National* exhibition were displayed in a par-
tially renovated dairy barn, attendees were undeterred by the ambiance. Nearly one-quarter
of the forty-five artists selected by the three jurors were from Ohio, which was not surprising
given the preponderance of quilt artists in the state.

Beth Gutcheon reviewed *Quilt National* for *Fiberarts Magazine,* with significant coverage that
included four quilts illustrated in color, by Nancy Crow (one of the show's organizers), Radka
Donnell, Nancy Halpern, and Wenda von Weise, plus black-and-white images of quilts by
Françoise Barnes, Tafi Brown, Rhoda Cohen, Virginia Randles, and Maria McCormick Snyder.
Interestingly, Gutcheon dismissed *The New American Quilt* exhibition as disappointing, while
remarking that *Quilt National '79* "has turned out to be the stimulating and all-encompassing
show one hoped for...."[140] Gutcheon pointed out that "the entries were limited to original
designs (no traditional work or work done under supervision)."[141]

The first *Quilt National* was a watershed event for contemporary quilt art. "Like the
Whitney show in the 1970s, Quilt National serves as the dividing line between what came
before and what was to follow."[142] The 1979 exhibition helped encourage several artists, for
example Tafi Brown, Terrie Hancock Mangat, and Katie Pasquini Masopust, to embrace the
quilt medium [Fig. 20].

Fig. 20. Terrie Hancock Mangat. *Giraffes* (1978, 96 x 86 in.).

Quilt National enhanced the reputations of every artist who had the good fortune to be included. Several had solo shows or other major exposure shortly after the 1979 exhibition. Radka Donnell, for example, had a solo show of fifteen quilts in 1980, at the Art Colloquium Gallery in Salem, Massachusetts. The review of Donnell's exhibition in *Fiberarts Magazine* by Pattie Chase illustrated five quilts in color, with an appreciation of "the sense of movement in the quilts, the rhythm of line and angle playing against the color and form to create an object of beauty and function that is simultaneously intended as a serious work of art."[143] Quilts were becoming part of the art world by 1980; Chapter Four will explore that development.

96 An example of this direct influence is Jane Burch Cochran, who wrote: "I met Terrie Mangat when she moved to Cincinnati and hers were the first art quilts I ever saw. I was a painter and hadn't planned on being a quilter. I started by making small fiber collages with beads, Xerox transfers and painted canvas. I finally made a large quilt in 1985. I would say that Terrie Mangat was my main inspiration." E-mail to the author, March 15, 2008.

97 William C. Seitz, *The Art of Assemblage* (New York: The Museum of Modern Art, 1961). The artists and critics thanked by the author in his acknowledgments are like a Who's Who of Alternative Art. He also thanks Lucy Lippard, now famous as a scholar of Feminism, for preparing the index.

98 By "fabric art" the present author means works of cloth or a material resembling cloth in which the primary design is on the surface; by "textile art" is meant woven, knitted, or crocheted cloth, or material resembling such cloth, in which the primary design is worked into the object. Both fabric and textile art are included in the term "fiber art."

99 Jack Lenor Larsen interviewed by Arline M. Fisch in 2004 for the Archives of American Art. http://www.aaa.si.edu/collections/oralhistories/transcripts/larsen04.htm.

100 Mildred Constantine and Jack Lenor Larsen, *Wall Hangings* (New York: Museum of Modern Art, 1969), pp. [3-4].

101 Mildred Constantine and Jack Lenor Larsen, *Beyond Craft: The Art Fabric* (New York: Van Nostrand Reinhold Company, [1973]). By the latter 1970s, "art fabric" generally came to mean cloth treated with surface design techniques and processes.

102 Larsen interviewed by Fisch.

103 *Beyond Craft: The Art Fabric*, p. 8.

104 Rose Slivka, "The New Tapestry," *Craft Horizons* 23 (Mar/April 1963), p. 10.

105 The square format of the catalogue and its dark, textured endpapers relate its design (by the Parsons School of Design) to the sort of chic catalogues being issued at the time by art galleries.

106 Paul Smith, *Fabric Collage* (New York: Museum of Contemporary Crafts [1965]), p. (5).

107 Azalea Thorpe New, "Young Americans 1969," *Craft Horizons* 29 (July/Aug. 1969), p. 9.

108 This information is recorded in the Archives of American Art, http://www.aaa.si.edu.

109 Sandra Zimmerman, *Sewn, Stitched & Stuffed* (New York: Museum of Contemporary Crafts, 1973), p. [24].

110 Obituary by Rita Reif, "Lee Nordness, 72, Art Dealer Who Promoted Crafts," *The New York Times* (May 23, 1995), accessed online in the newspaper's archives.. As most readers may know, gender-neutral language had not yet been considered. All craftspeople were called "craftsmen." Today it seems quite odd to read that a female artist's solo exhibition was referred to as a "one-man" show.

111 Lee Nordness, *Objects : USA* (New York: The Viking Press, 1970), p. 280.

112 Op. cit., p. 320.

113 John Ashbery, "The Johnson Collection at Cranbrook," *Craft Horizons* 30 (Mar./Apr. 1970), p. 35.

114 Phone interview with the author, February 26, 2007.

115 Cynthia Nadelman, "Fabric in Art," *Art News* 79 (September 1980), pp. 244-247.

116 Marie Lyman, "Boxes and Robes: Wrapped and Unwrapped Forms," in *Delectable Mountains* (Portland: Morning Light Studio, 1982), p. (5).

117 Lois Allan, "'The Cancer Project' Provides Psychic Healing," *ProWOMAN Magazine* (October/November 1990), p. 45.

118 Jenny and Francis Guth, "Venice: The Biennale," *Craft Horizons* 24 (Sept./Oct. 1964), p. 48.

119 Alice Adams, "Frances Robinson," *Craft Horizons* 21 (May/June 1961), p. 42.

120 Alan Meisel, "Letter from San Francisco," *Craft Horizons* 26 (June 1966), pp. 87-88.

121 Jonathan Holstein, *Abstract Design in American Quilts: A Biography of an Exhibition* [re-creation at the Louisville Museum of History and Science of the 1971 Whitney exhibition] (Louisville: The Kentucky Quilt Projector, 1991), pp. 216-217. The original 1971 catalogue has only 16 pages, with seven illustrations. It is interesting to note that the 1971 exhibition and catalogue were dedicated to Holstein and van der Hoof's friend, the abstract painter Barnett Newman (died 1970), who had encouraged them to exhibit the quilts in a museum in New York City. Quilts from the Holstein-van der Hoof collection were also exhibited in museums in Paris and Lausanne (1972), Bristol (1975), and Kyoto (1976).

122 Op. cit., p. 214.

123 Op. cit., p. 21.

124 See the "Joyce Gross" biography online in www.centerforthequilt.org.

125 The combination of quilts and wood, ceramics, or glass was utilized in several exhibitions during the 1970s, such as the large-scale quilts of Susan Zucker and the "architectural" wooden structures of David Durst show together at the Hudson River Museum in 1979.

126 Nancy Halpern, *Northern Comfort: Three Hundred and Fifty Years of New England Quilts* (unpublished manuscript, completed in 1983), Chapter IX, p. 11.

127 On July 4, 1976, the present author was in New York, sewing the binding on a traditional *Moon Over the Mountain* quilt created for a friend who lived in the city. That commission resulted in the opportunity to view *The New American Quilt*.

128 Phone interview of May 27, 2008.

129 Halpern, op. cit., Chapter IX, p. 12.

130 Erica Wilson, *Erica Wilson's Quilts of America* (Birmingham, AL: Oxmoor House, 1979), p. 1.

131 Lisa Hammel, "Quilts: A Folk Idiom That Has Come of Age," *New York Times* (April 9, 1976).

132 Jean Libman Block, "A Quilt is Built," *Craft Horizons* 36 (April 1976), p. 31.

133 N.F. Karlins, "New & Newer Quilts," *Quilter's Newsletter Magazine* 7 (August 1976), pp. 19-21.

134 Gayle Pritchard, *Uncommon Threads: Ohio's Art Quilt Revolution* (Athens: Ohio University Press, 2006). p. 11. This excellent book is a fount of information about the contemporary quilt art movement in Ohio.

135 "Virginia Avery," in the Quilters Hall of Fame web site, http://www.quiltershalloffame.net/Avery.html (July 3, 2008).

136 E-mail from Karey Bresenhan to the author, July 8, 2008: "The first special exhibit at Festival to feature art quilts was the 1984 exhibit 'New Directions for an American Tradition,' which was the Quilt National 1983 touring exhibit. All of the brochures prior to 1984 only mention antique/traditional quilt exhibits." As for the International Quilting Association exhibitions, Karey recalls that in 1982 a quilt by Katie Pasquini Masopust won Best of Show, which may have been the first time that a studio quilt was awarded that honor. I am very grateful to Karey for this information.

137 David L. Shirey, "A Bright New Wrinkle for Quilts," *The New York Times* (February 27, 1977), accessed online in the newspaper's archives.

138 Glen Kaufman, "Fiber" in "Young Americans: Fiber/Wood/Plastic/Leather," *Craft Horizons* 37 (June 1977), pp. 15, 69-70.

139 See http://www.quiltnational.com/. There unfortunately was no published catalogue. The jurors were Michael James (a quilt artist), Gary Schwindler (an art history professor), and Renee Steidle (a gallery owner).

140 Beth Gutcheon, "Quilt National '79," *Fiberarts Magazine* (Sept./Oct. 1979), p. 80.

141 Ibid.

142 Pritchard, op. cit., p. 48.

143 Pattie Chase, "Radka Donnell: Patchwork Quilts," *Fiberarts Magazine* (Sept./Oct. 1980), pp. 76-77.

CHAPTER 3:
POLITICS AND ALTERNATIVE
LIFESTYLES

The tumultuous political movements of the 1960s and 1970s contributed to the transformation of quilts as contemporary art in several ways.[144] Helen Bitar says, "My work became inspired by the bright freshness of the sixties. Of course, who was not influenced then?" Even those who were "not involved" with political issues were affected, as they reacted by embracing ethnic identities, the pure focus of aestheticism, or alternative lifestyles.

The most senior artist featured in the present book was born in 1923, the youngest in 1957, with the majority born before 1950. The younger artists discussed here felt the repercussions of the latter 1960s and early 1970s as teenagers, an especially sensitive and impressionable stage of development. Several have remarked that although they did not participate in or directly experience political movements, they benefited as college students attending schools such as the University of Wisconsin where liberal attitudes had produced more flexible and open approaches to learning.[145] Such "open" attitudes extended to the materials and processes used in the art created by these individuals.

NATIONAL POLITICS

This section deals with racial politics, the Vietnam War along with the antiwar movement, and environmentalism. In some instances, these topics prompted the creation of quilts before 1980; in others, the turmoil of those years came to the surface much later, inspiring quilt art of the 1980s and 1990s.

Racial Politics

For several artists, their protests against the U.S. involvement in Vietnam were instigated as activism against what they perceived as a WASP establishment condoning racism and other injustices. Geographically, most of the artists in the present book were far removed from overt civil rights activities. An exception is Jane Burch Cochran, who marched with Martin Luther King, Jr., in Frankfort, Kentucky, for fair housing. Bets Ramsey, living in

Alabama from 1952 until 1957, was at the University of Alabama when the first African-American student arrived. Ramsey's husband chaired an Open Forum meeting that was picketed by the Ku Klux Klan. Ann Sargent-Wooster lived in the northeast, but her minister was killed in Selma, Alabama, while working for racial quality—an event still fresh in her memory.

Several quilt artists were members of organizations laboring to abolish racism, such as the NAACP and CORE. We have evidence of quiltmakers who not only were involved in civil rights actions, but also were punished for it. Jessie Telfair, an African-American, was fired from her cafeteria job in 1975 because she voted in a general election in Parrott, Georgia.[146] Her *Freedom Quilt* responded to this attack in red, white, and blue, with lettering that exuberantly spells "freedom." The African-American quiltmakers of Gee's Bend, Alabama, also were affected by the struggle for the right to vote, as evidenced in a *Housetop* quilt (c. 1975) by Irene Williams.[147] This and several other quilts were made using a red, white, and blue fabric printed with the word "vote."

Carolyn Mazloomi's experiences as an African-American woman during the 1960s and 1970s have directly contributed to imagery in her quilts. She began attending college at Grambling, but was expelled for protesting the college's emphasis on athletics—a protest requiring response by the National Guard. Mazloomi then attended Tuskegee Institute (1965-1966), recalling Dr. King recruiting on the campus and the bombings in Birmingham. While driving alone across Mississippi, she was arrested in Tougaloo for "speeding" and harassed by members of the local police force. Civil rights leaders had just been murdered, and Mazloomi remembers that the town had a street named "Lynch Street." ("Lynch" actually was a family name, but for her it had a very different meaning.) Escaping the racism prevalent in parts of the South, she moved to California, earned her pilot's license and a degree in aircraft maintenance, and finally a Ph.D. in aerospace engineering. Nevertheless, Mazloomi's treatment in Tougaloo remains vivid to this day, and the African-American themes in her quilts have provided a personal antidote to that sort of bigotry.

The political forces behind African-American quilts (of all types) during the 1960s and 1970s would require a separate book in itself. Two excellent books that document these contemporary quiltmakers are Roland L. Freeman's *A Communion of the Spirits* (1996) and Carolyn Mazloomi's *Spirits of the Cloth* (1998). Both books are comprehensive and inclusive, not distinguishing studio quilts as such within the larger African-American traditions. Clearly, the political and social upheavals of the 1960s and 1970s have made a significant impact on the African-Americans featured in these two books, with many of them creating quilts of originality and power. Premier among them would be Faith Ringgold, who reminds readers: "Along with jazz, quilting is the uniquely American contribution to world art that bears the legacy of our own African heritage and carries it into our common future."[148] Carolyn Mazloomi founded the Women of Color Quilter's Network in 1986, an indirect result of the black women's liberation movement in the latter 1970s, of which Ringgold was a founding member [Fig. 21].

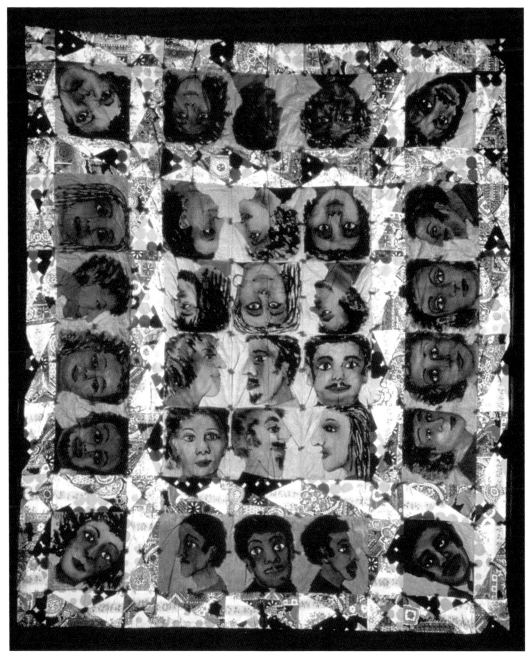

Fig. 21. Faith Ringgold. *Echoes of Harlem* (1980, 96 x 84 in.), © Faith Ringgold 1980.

Faith Ringgold has combined political activism and art activities since she was a student. "Seldom has she divorced the politics of art from its often-unacknowledged cultural base, reasoning that an activist approach in art matters is indeed an important course of action."[149] As the art world assimilated quilts during the 1970s without recognizing the inherent aesthetic value of quilts per se, both Ringgold's and Miriam Schapiro's "insistence on the specificity

of their materials and patterns as feminine and/or African-American in origin carries an oppositional charge."[150]

Vietnam and the Antiwar Movement

The Vietnam War directly affected several of the artists in this book, especially Arturo Alonzo Sandoval and Michael Cummings, both available for military service in the latter 1960s. Sandoval received two medals for his tours of duty, an important part of his personal history in light of the very charged political imagery in some of his later studio quilts. Sandoval's earlier work featured monumental installations of abstract, ephemeral forms [Fig. 22].

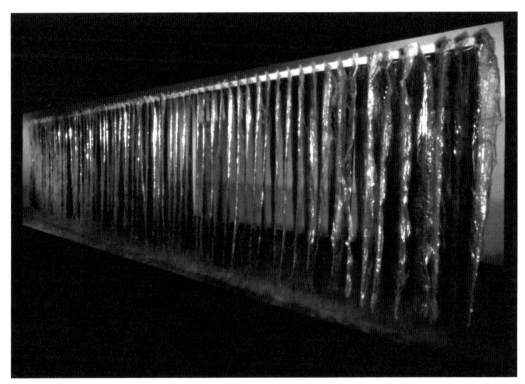

Fig. 22. Arturo Alonzo Sandoval. *Red Sky* (1975, 72 x 432 x 18 in.). Inspired by diaphanous cloud formations in New Mexico at sunrise and sunset, the modules of this monumental work are installed on an armature to be viewed in the round.

Michael Cummings recalls his own reactions, especially: "The unrest in the urban community … and an international war taking thousands of young men to a jungle as a traumatic experience…. I had seen many friends go off to die, leaving crying parents, sisters, brothers, and friends." Cummings's sense of alienation was compounded by the fact that he is African-American and at that time was living in "make-believe" Los Angeles, "far away from the civil rights marches in the South." The intensity of this period resurfaced in Cummings's quilts, in which he celebrates his African-American heritage [Fig. 23].

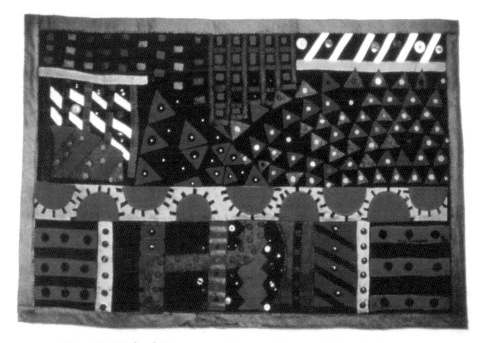

Fig. 23. Michael Cummings. *Time and Space* (1976, 48 x 72 in.).

Sas Colby's husband served in Vietnam as an Air Force pilot, an experience that energized her political conscience. She was "disillusioned by the discrepancy between what was happening and what we were told was happening." Colby developed a long-lasting belief in world peace. (In 1988 she created a mail art series titled *The Peace Envelopes*.) Carolyn Mazloomi is among the artists who had family members serving in Vietnam, with two brothers in combat. She recalls the horror of seeing images from the war on television.

Many quilt artists demonstrated or wrote letters protesting the U.S. involvement in Vietnam. Terrie Hancock Mangat protested against the war and "ran with radicals." As high school students, Paula Nadelstern and Robin Schwalb participated in the 1968 March on Washington to protest the war. Nadelstern was already involved with socialist politics, and Schwalb was developing a sense of social awareness that still informs the texts and images in her quilts. Ed Larson, who was living in Chicago during the late 1960s, remembers being appalled by the violence of the 1968 Democratic National Convention. He marched to protest the Vietnam War while feeling strongly rooted in patriotism and "American themes," such as his love for baseball. Most of his quilts have featured Americana themes. Nancy Halpern supported the radical Peace and Freedom Party during the late 1960s, and came close to voting for Eldridge Cleaver.

Susan Shie, a student at Kent State University, marched against the war and protested the Oakland Police Department's recruiting at Kent Sate because of the blatant racism in Oakland at that time. Kathleen Sharp demonstrated against the war and signed petitions. Several of the artists discussed here were too young to protest, but nevertheless remember being shattered by the assassinations of John F. Kennedy and his brother Robert Kennedy, and of Martin Luther King, Jr. At the time of J.F.K.'s assassination, Patricia Malarcher had a commission to create a vestment for the pastor of an African-American church in Washington, D.C. She used blue, signifying hope, rather than penitential purple, for the Advent season. Malarcher and her

husband worked on the vestment together, and "the comfort of fabric carried us through that terrible time."

Bonnie Peterson initially did not react personally against United States politics, but then she visited Zaire in the 1970s and realized that the United States was supporting the dictator Mobatu. Peterson learned to question governmental authority, an attitude that has contributed to the political focus of her studio quilts.

Other quilt artists did not personally protest United States policies, but agreed with those who were publicly demonstrating. Both Jean Ray Laury and Nancy Erickson were active in various peace groups, including the Women's International League for Peace and Freedom. Their politics have fed directly into the themes of their quilt art. For some, such as Therese May, their political attitude derived from a deep spiritual hope for world peace. The very symbols of spirituality, such as the god's eye and the mandala, became important motifs in quilts. One example by Beth Gutcheon, framed by three-dimensional quilted triangles, was published in color in 1978.[151] Katie Pasquini Masopust's first book, published in the early 1980s, is titled *Mandala* and discusses the spiritual background of this image [Fig. 24]. The emotional toll on the sensibilities of artists during this era can be summed up by Judith Content: "I remember when the Vietnam War ended—I cried."

Fig. 24. Katie Pasquini Masopust. *Nova* (1980, 80 x 80 in.).

Environmentalism

Other individuals rebelled against the entire "consumer society" described at length by John Kenneth Galbraith in *The Affluent Society* (1958). Linda MacDonald, for example, explains that during the 1960s she was "reacting to what was going on by rejecting [the] … middle-class security-driven lifestyle and getting along with barely anything." For seven years Macdonald and her family went "back to the land," (see below) living in a cabin in the wilds of Mendocino County in northern California. Her fierce environmentalism was born here. While Jane Burch Cochran was not directly involved in environmental politics, she was living in rural Kentucky during part of the 1970s, learning respect for the land as her family gardened and composted. She "learned to love the country, and to quilt, from being a real city girl." Beth Gutcheon experienced "grass roots hippie back-to-the-land stuff" when her family spent their summers in a tipi.

Susan Shie was "always supportive of ecology," and became more active when the necessity of recycling became obvious. Her environmentalism of the 1970s was the background to her creation of the Green Quilts project in 1989, a project that continued until 2004.[152] Jeanne Williamson was involved with recycling as a high school student. Her Junior Achievement project in 1972 was to start her town's first recycling center. She says, "We collected glass bottles and tin cans, and spent our Saturdays smashing the glass in huge tin drums, and flattening the cans." Today, Williamson is "recycling" plastic orange construction fencing in her quilts. Arturo Alonzo Sandoval's first wall piece was constructed of interlaced, stitched Mylar, titled *Pond with Scum*, a reaction to Lake Erie being declared "dead." An entire body of work consisting of recycled materials, which he continues to use today, followed that piece.

Bonnie Peterson's concerns about ecology stem from her early enthusiasm for backcountry hiking and kayaking. Several of her later quilts celebrate national parks and other wildlife habitats. Wendy Huhn, who considers herself "very political," worked to support legislation that saved a local river. During the 1970s she was also enjoying the wilderness, spending six weeks running the Colorado River in the Grand Canyon.

Nancy Erickson's husband was cofounder and director of the Environmental Studies Program at the University of Montana, and Erickson has been involved in environmental issues for decades [Fig. 25]. Some of her work during the 1960s addressed the problem of clear-cutting timber, and during the 1970s she made environmental statements in small three-dimensional fabric objects, such as a buffalo and a stump. Erickson witnessed many people completely changing their way of life. (She still has a solar water heater from the Jimmy Carter era that functions during the summer.)

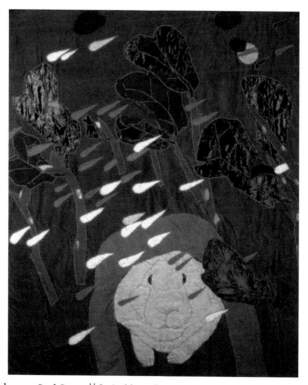

Fig. 25. Nancy Erickson. *Red Rain #2: Rabbit Alone* (1978, 108 x 84 in.). Second in a series of six quilts featuring the artist's pet rabbit.

53

FEMINIST POLITICS

Robert Shaw has remarked, "Caught in societal stereotypes, male artists and art theorists did not begin to examine or find strength in the quilts until the 1970s. It is largely women artists who have had to reclaim the quilt and its history as their own, and have begun to free it from its former constraints."[153] Women's liberation and feminist politics very much motivated quilt artists, who purposefully chose to work in a traditionally female genre. Many of the artists in the present book consider themselves as having been either interested by or involved in nascent feminism. Ed Johnetta Miller, for example, remembers being motivated by lectures that she attended. The 1970s effected "a real transition" in her life, when Miller left administrative work and experienced "an explosion of creativity." Patricia Malarcher, who was developing her personal artistic voice during the early 1970s, marched down Fifth Avenue in the 1970 Women's Liberation protest led by Betty Friedan, accidentally meeting her own mother along the way. Her feminist inclinations have been most vocally expressed in relation to the suppression of women's voices in the Catholic Church. Sas Colby joined the Connecticut Feminists in the Arts group in 1971, and describes it as "a lively and energetic group of creative women ... many from NYC."

Robin Schwalb, in spite of the fact that she describes herself as "rather apolitical," raised money to support the Equal Rights Amendment and volunteered at the National Organization for Women. Sue Benner remembers her discovery of the book *Our Bodies, Ourselves* (1973): "I felt that it was very important for women to know about their bodies and be responsible for their own well-being and sexuality. These same ideas are what brought me in part to illustrating the human reproductive system [in fabric] for my thesis" [Fig. 26].

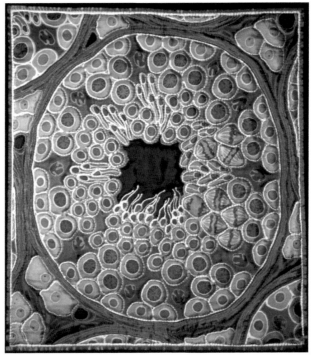

Fig. 26. Sue Benner. *Seminiferous tubulae: mature* (1980, 30 x 24 in.). Created as part of a master's thesis in Biomedical Communication/Medical Illustration at the University of Texas Southwestern.

California artist Jean Ray Laury was the most significant forerunner of this revolutionary movement among quilt artists, when quilts began to be viewed as contemporary art. Miriam Schapiro and Judy Chicago, both of whom produced works using fiber and textiles with distinct references to quilts, also served as strong role models [Fig. 27]. The theoretical stance of "quilt poetics" has been created to describe this politically charged medium, positioning studio quilts as a link between crafts and art (see Chapter Four).

Fig. 27. Miriam Schapiro. *Souvenirs* (1976, 40 x 32 in.). Vintage textiles "femmaged" into a painting.

Jean Ray Laury

Well before the feminist movement blossomed in the 1970s, Laury was empowering her (mostly female) students and readers with her publications, reinforced by the example of her own independent, original work. Quilt artist Sue Pierce has said of Laury: "She was one of the first people publicly to champion the fact that fiber creations that had commonly been known as 'women's work' should be seen as serious art expression" [Fig. 28].

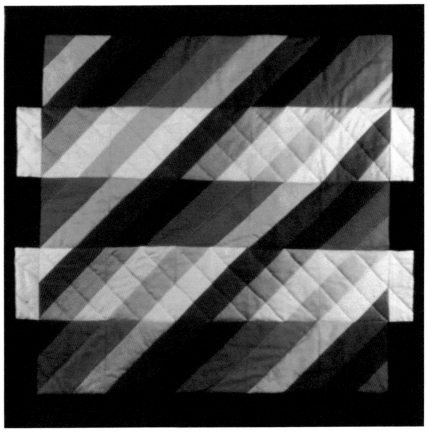

Fig. 28. Sue Pierce. *Overlay Two* (c.1981, 30 x 30 in.).

Laury's most influential book is probably *The Creative Woman's Getting-It-All Together at Home Handbook* (1977). This publication is based on conversations with and letters from fiber artists from around the country, especially those who had taken Laury's workshops and mentioned the frustrations of combining the careers of homemaker and artist. Sprinkled with the author's own anecdotal advice, the text speaks out in the words of all these women attempting to carve time from their daily lives so that they could pursue their parallel lives as artists. Even though Laury's attitude seems relaxed and nonpolitical, the book itself is very political as other women voice their concerns and suggest ideas for effectively managing one's time.

Jean Ray Laury was at the leading edge of a tidal wave of feminist art that first appeared on the academic horizon at California State University, Fresno, in the early 1970s (see below). Although Laury's attitude was nonconfrontational, her encouragement of women's work was as effective as that of more politicized teachers, and Laury's husband, Frank Laury, joined her in supporting feminist art activities. As head of the Department of Art, he hired Judy Chicago to teach at Fresno. But several years before Fresno was fired up by Chicago into a hotbed of feminist art, Laury had published her first two books, *Applique Stitchery* (1966) and *Quilts and Coverlets* (1970). In an online survey that I conducted in 2005, fiber artists of international repute responded that these two books were instrumental in their artistic

development, chiefly because the text and images gave them "permission" to explore fiber as a viable creative medium.

Laury stated in the introduction to *Applique Stitchery* that "art has less to do with the material used than with the perceptive and expressive abilities of the individual. Any difference between the 'fine' and the 'decorative' arts is not a matter of material, but rather what the artist brings to the material. Any media may successfully be used at any level for any purpose." This creative principle is the driving force of another feminist artist, Miriam Schapiro (see below), whose technique of not just collage, but *femmage*, served as another inspiring example for quilt artists during the latter 1970s. Schapiro especially advocated recycling women's materials, such as lace handkerchiefs, aprons, and household textiles.

Quilts and Coverlets was an important book for quilt artist Dominie Nash. She read it in the mid-1970s before she began making quilts as an art form. Nash wrote, "I had made some rather crude and strange quilts for the family, and seeing all of the wonderful work in her book gave me permission to continue in that direction, rather than heeding the more conservative voices coming from the quilt community" [Fig. 29].

Fig. 29. Dominie Nash. *Convergence* (c.1975, 31 x 41 in.). This breakthrough piece taught the artist about the relationship between creativity and happy accidents.

Quilts and Coverlets featured Laury's quilts along with work by Else Brown, Charles and Rubynelle Counts, Molly Sue Hanner, Joan Lintault, Therese May [Fig. 30], and others (see Chapter One).

Fig. 30. Therese May. *Therese* (1969, 90 x 72 in.). Self-portraits of the artist, using fabrics cut from used clothing purchased in thrift stores.

This was a how-to book like nothing anyone had ever seen, a thorough documentation of how the 1960s had irrevocably changed the world of quiltmaking in this country. From pure abstraction to tie-dyed patterning to stylized portraiture, contemporary studio quilts were ingeniously juxtaposed with more familiar designs by Laury that incorporated humor and mundane yet elegant objects. By bringing the new medium of quilt art to readers (which meant mostly female readers) in such an encouraging, safe environment, Laury opened a creative door for many women who might never have purchased the book had it been titled *The New Quilt* or included the word *art* in the title. "*Quilts and Coverlets*"—what could be less confrontational? In the introduction to this book, Laury made its purpose very clear: "Only recently is the influence of contemporary art … seen in our quilts. Modern designers of quilts are not concerned with reiterating statements made years ago. They have their own comments to make, comments which are relevant to our own times."[154]

Miriam Schapiro and Judy Chicago

Influential feminist contemporary art during the 1970s included the avant-garde pattern and decoration work of painter Miriam Schapiro and the needlework projects organized by Judy Chicago. The latter's controversial imagery assured her national press coverage, and Schapiro propagated her feminist ideology during numerous campus visits across the country. Susan Shie is among the contemporary quilt artists encouraged to use textiles in her work partly because of Schapiro's lectures. [155]

Although female artists were certainly recognized in this country before the end of the 1960s, their artistic styles, for the most part, conformed to the dominant modes of male artists, notably Abstract Expressionism and Minimalism from the 1950s through the 1970s. The content of the works of female artists had little basis in women's history or women's experiences. During the latter 1960s, Judy Chicago, for example, was painting large-format expressionist lifesavers in colors of the rainbow. Miriam Schapiro was painting hardedge geometric shapes. (In retrospect, both artists incorporated several of these works into the background story of their nascent feminism.)

Chicago and Schapiro engendered the feminist art movement that burgeoned in southern California in the early 1970s. Schapiro had moved there in 1967 when her husband, Paul Brach, became chair of the Art Department at the University of California, San Diego, in La Jolla. In 1970 he was appointed dean of the newly established California Institute of the Arts (Cal Arts), located in Valencia (about an hour's drive from Los Angeles). Chicago herself was in Fresno in the fall of 1970, having accepted a one-year teaching position at Fresno State College to establish the Feminist Art Program.

Chicago's purpose there was to create a studio environment exclusively for female students, interviewing and then selecting only those students whom she believed would develop into serious artists. Sas Colby, who was a visiting artist at the school from 1972 to 1973, participated in the exploration of feminist issues being taught by Joyce Aiken in her Feminist Art course [Fig. 31].

Fig. 31. Sas Colby. *Figure Quilt* (detail, 1975).

Many of the early classes in the program functioned as "consciousness-raising" seminars, before feminists began using the term. Kathleen Sharp was one of the quilt artists who belonged to such a group, in which she "came to recognize myself as a feminist," and became committed to activism on a day-by-day basis.

Schapiro and Chicago worked as a team to establish the Feminist Art Program at Cal Arts, a goal fulfilled in the fall of 1971. Moreover, several Cal Arts students in a research seminar had been amassing information on women artists for an archive at Cal Arts. Schapiro's assistant made slides for visual documentation, and the first illustrated database of women's art was created. By the Fall term of 1972, Arlene Raven had been hired to teach art history at Cal Arts, including art history "from a woman's point of view" for the Feminist Art Program.[156] Cal Arts was a very "happening" place in the early 1970s. Sheila de Bretteville, for example, established the Feminist Design Program there. In 1973 she founded the Feminist Studio Workshop in Los Angeles, along with Chicago and Arlene Raven.[157]

The purpose of the Feminist Art Program at Cal Arts was to "help women restructure their personalities to be more consistent with their desires to be artists and to help them build their art making out of their experiences as women."[158] Quilts and quilt-like surfaces would prove to be an effective part of that female experience.

Both Chicago and Schapiro believed that the art world stifled the creativity of female artists, forcing them to function within uninspiring male paradigms. Chicago's classes at Fresno State were the first instance on the West Coast of female students making art within an all-female environment, and women came from Los Angeles and other cities to experience the art works and performances. These classes became famous throughout the state, with quilt artists hearing about what was going on from friends, colleagues, and the press.

Schapiro and Chicago realized that they were involved in an historic endeavor at Cal Arts, and they wanted their major project for the school year to be memorable. Art historian Paula Harper, who taught at the school, suggested that the students might collaborate on installations in an abandoned house, which would be called *Womanhouse*. The completed project would feature feminist art by the students, Chicago, and Schapiro, as well as by three local artists invited to participate in the project. One of the three was Carol Edison Mitchell, whose contemporary quilts were displayed in *Womanhouse*.

In January of 1972 the installations were almost completed and people were beginning to come view the house. It was opened to the public on January 30, 1972, and closed on February 28. The annual conference of the College Art Association had ended in San Francisco on January 29th, and many of the attendees came to Los Angeles afterwards, with *Womanhouse* among the exhibitions that they visited.[159] Nearly 10,000 people visited *Womanhouse*, and the exhibition received coverage on national television and in popular magazines, such as *Time* (where the review was entitled "Bad-Dream House").[160] It was also reviewed in the *Los Angeles Times* during the final week of the exhibition.[161]

Miriam Schapiro's work for *The Dollhouse* in *Womanhouse*, in which Sherry Brody assisted her, marked a turning point in Schapiro's career. As Thalia Gouma-Petersen explained, "it made her see art-making from another perspective—from 'the eyes of a woman.' The piece is full of textiles. *Dollhouse*, to some a 'frivolous work,' released Schapiro from the previous imperatives to create mainstream art She transformed her private life into a public act, validating the traditional activities of women, which she had, until then, dismissed."[162]

The creative process of self-exploration and self-realization was the main purpose of *Womanhouse* and of the Feminist Art Program. Arlene Raven explained the artists' experience in *Womanhouse* as a powerful confrontation with issues of identity, in which the students learned that "what we 'make' of our lives is an invention of meaning and human triumph or despair. And no one else can take up for us the burden of being ourselves."[163] Feminist themes and symbolism surfaced in quilt art during the mid-1970s. One blatant example, by Evelyn H. Hebner, "is covered with bras—more than a score of colorful, plain and fancy, lacy and utilitarian bras. ... /... [and] our contemporary culture is concerned with the same subject matter as this quilt."[164] Women's lingerie has continued to be associated with issues of identity and healing, in various forms of fiber art. Such works are a direct result of "the priority that seventies feminist aesthetics placed on the autobiographical."[165]

ALTERNATIVE LIFESTYLES

The hippie movement is linked with those who went "back to the land" because both groups attempted to shun or ridicule modern society, and there was overlapping among the two. Hippies also dabbled in various mystical or primitive belief systems, such as astrology. Linda MacDonald, for example participated in the Human Be-In in Golden Gate Park, and her "hippie/artist" wedding featured a large chocolate cake decorated with the bride and groom's astrological symbols. Jane Burch Cochran had a business in Cincinnati selling "hippie costume jewelry," with motifs such as the moon and stars.

Many quilt artists, without dropping out and becoming actual hippies, had an affinity for hippie style in textiles and fiber, such as tie-dyed fabric and free-style embroidery. So-called peasant styles also became popular, partly through hippie influence.[166] Carolyn Mazloomi has used tie-dyed fabrics since they first became popular, explaining, "Still to this day, I love tie-dye—reminds me of the hippies, that freedom."[167] Kathleen Sharp also liked the creativity of hippie style.

In his June 1976 column for *Craft Horizons*, Ed Rossbach wrote, "The imagery of the local scene is in Katherine's [Westphal] printed and embroidered textiles. She uses tie-dye and fold-dye as backgrounds (which now seems an old-fashioned word) for flower children, Hare Krishna messages, the palm trees of People's Park. In my constructed pieces and in my silk-screened textiles, I have used Mickey Mouse, assassin handguns, cosmic spheres. The influence of the Berkeley scene is evident, too, in ways less easily described in a few words."[168] Therese May was struck by "the resurgence of crafts, and the idea of going back to basics and doing things yourself. I was very inspired by some of the art that was being done in the Bay area."

Native American Art

The handwork of Native Americans (popularly known as "Indians" during the two decades covered by the present book) also inspired quilt artists [Fig. 32]. Terrie Hancock Mangat, for example, taught herself how to do reverse appliqué by studying molas from the San Blas Indians of Panama. The "authenticity" of traditional Native American lifestyles appealed to many people during this era.

Fig. 32. Jane Burch Cochran. *Indian Madonna* (1980, 12 x 12 in.). The artist's second quilt, part of a triptych.

Seminole patchwork was "developed by the Mikasuki-speaking Seminole Indian women of southern Florida around the end of the 1800s."[169] While most of the quilts created by Native Americans featured nonnative patterns taught in the mission schools, the strip-work technique of Seminole designs was truly indigenous, though prompted by new technology. Prior to c. 1900, Seminole women in south Florida "had long been making clothing of colorful cotton cloth, some print, some plain. They had also done geometric appliqué and simple piecing by hand. With sewing machines and an ample supply of fabric, the women sewed rapidly, and they began to experiment with new ways of making patterns.... Now the tear sizes became smaller and were sewn together in long strips of two colors. These strips were cut and joined to form new patterns that were much more intricate than the earlier hand appliqué."[170] Tourists purchased craft objects featuring the new patterns, transporting their souvenirs throughout the United States, thus disseminating the Seminole style far from its origins [Fig. 33].

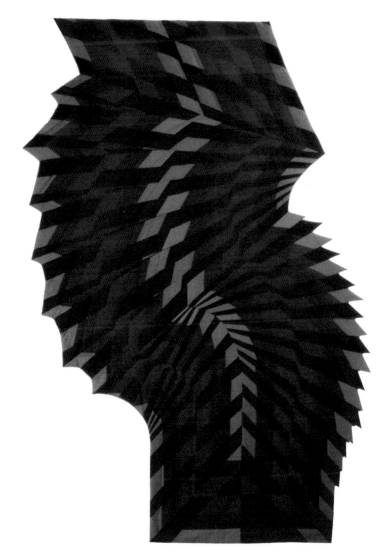

Fig. 33. Joy Saville. *Seminole Study III: Gravity & Grace* (1981-82, 92 x 68 in.). The artist was exploring how the angles of strip piecing created both shape and movement. This technique of Seminole strip work was instrumental in Saville's evolution of her signature style.

Native American art from the southwestern United States and the Plains Indians, especially fiber and ceramics, has been particularly appealing to quilt artists, partly because "the motifs in … textiles, basketry, and pottery are usually highly stylized."[171] For example, the stripes and diamonds in a Navajo blanket could easily be translated into other textiles. The Southwest provided artists working "in fabric and thread an opportunity to be outrageous, bold, different, and pioneering."[172] Jane Burch Cochran was influenced by the beadwork of the Plains Indians during the late 1970s, deciding to include beads in her quilts as a result. She even had a beaded buckskin dress and quill earrings. Several Caucasian quilt artists studied the designs in Seminole patchwork and Native American weaving, adapting them for contemporary quilt art.

The earliest known fiber group influenced by Seminole strip-work was the Unorganized Stitchers, formed by Jacqueline Enthoven in 1969 in the northwestern United States.[173] Their members included Pat Albiston, Flo Wilson Campbell, Jill Nordfors, Sue Roach, and Carol Tate. These individuals exhibited quilts created with Native American techniques and motifs. Jane Lang Axtell, Helen Bitar, Michael James, and Joy Saville are among the other quilt artists whose work has been influenced by Native American art.

The Hippie Movement

Susan Shie's outspoken comments about her own influences provide a provocative introduction to this topic: "I really believe that the women's movement and the hippie movement formed the art quilt movement, and that this is the *only* art form to have been born from those two movements merging.... I believe that what we've done in our art will be appreciated more *as* a movement when art historians look back on it. People can't see it as clearly now, but it's very profound and solid." Even today Shie's studio quilts have the heavily handcrafted look popularized by hippies, who decorated everything from hats to blue jeans [Fig. 34].

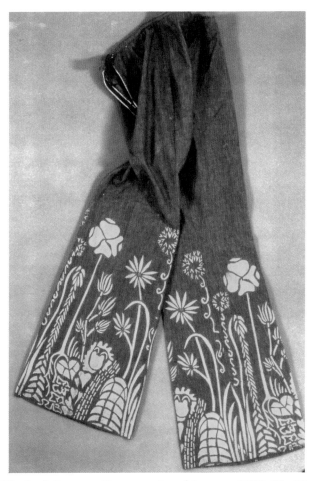

Fig. 34. Elizabeth Barton. (Screen-printed jeans, c.1970-72, 40 x 24 in.).

The Hippie Movement, of course, refers to the late-1960s counterculture phenomenon whose adherents were given the rubric "flower children" and then "flower people" in the early 1970s when millions of flower people were turning away from mainstream American values. Although evolving from the same protest movements as the leftist radicals in Students for a Democratic Society and similar groups, the hippies were more interested in making political statements through their permissive lifestyle than through political demonstrations per se. While Ann Sargent-Wooster was a member of S.D.S. and "dressed as a hippie," she did not embrace the communal lifestyle because she thought that it was "too hard on women." While very few of the artists in the present book lived in communes or habitually used psychedelic drugs and other controlled or unusual substances,[174] several experimented with LSD, marijuana, or mushrooms, and several others lived on the fringes of hippie communities, seeking freedom from the "consumer society." One artist interviewed for this book describes LSD trips as "breaking through the veil" and "a marked point" in artistic development.

People in this country at every socioeconomic level were very aware of this newly found "freedom" because of ubiquitous broadcasts via national television of the original Haight-Asbury scene, and of the Yippies who gained international notoriety in 1968. Although their type of extreme behavior was not, as far as I have been told, part of the personal history of quilt artists, such flaunting of authority and insistence on personal expression did indeed appeal to many of the artists in the present book.

Patchwork began to have a universal appeal during the 1960s, with vintage quilts and quilt tops cut apart for the production of decorative pillows and other household goods. This craze was described in newspapers across the country. In 1969, the *New York Times* reported, "One of the newest ways to look this summer is old-fashioned, but not just any version. It must be patchwork, preferably from the attic trunk or an antiques shop. When this isn't possible, the newly produced patchwork-by-the-yard will do, and tens of thousands of yards are now being shaped into dresses, coveralls and skirts of every length."[175] The domestic textile industry had its finger on the pulse of the public.

Virtually anything handmade with an ethnic or rural flavor was in vogue. One summer during their college years, Susan Hoffman and Molly Upton opened a shop, the Front Porch Out Back, in a small barn near Upton's family's house in Weston, Vermont. They painted the name on an antique pickup truck parked near the entrance, and did a brisk business in mobiles, necklaces, and other handmade items.[176] Funky decoration, including surfaces shimmering in beads and sequins, appealed to several quilt artists. The influence came from various sources. Ed Johnetta Miller's father, who owned a dry-cleaning business, brought home silk costumes, such as those of singer Rosemary Clooney, to remove small stains by hand. Seeing these garments up close, Miller gained a respect for beading and an "absolute love of fabric."

Elizabeth Barton (born in England) "sewed and sewed and sewed" after her first trip to the U.S. in the late 1960s, experimenting with various styles of stitchery. Paula Nadelstern become enamored with the peasant style and handcrafted surfaces typically found in hippie communities, embroidering her own clothes and crocheting colorful bags to sell. The motifs of circular, concentric flowers and stars in these objects seem to prefigure her later kaleidoscopic quilts [Figs. 35 and 36].

Fig. 35. Paula Nadelstern. (motif embroidered on blouse, 1970s).

Fig. 36. Paula Nadelstern. *Kaleidoscopic XII: Random Acts of Color* (detail, 1994).

A few artists, such as Joan Lintault, had on-site experience with ethnic textiles. She lived in Peru with the Peace Corps from 1963 to 1965, setting up a crafts cooperative and teaching weavers, knitters, and dyers to improve the durability of their work by using colorfast dyes.

Back to the Land

Several quilt artists moved to rural areas, or were taken to rural areas when their parents made a commitment to return to a more "authentic" lifestyle. Wendy Huhn's alternative life-style was probably the most extreme of any in this book. She and her family managed to live for two-and-a-half years in two old school buses (1953 GMC, to be precise) while they built their log house. With a Merry Prankster for a neighbor and limited space for creating art that caused her to turn to fabric for self-expression, Huhn fulfilled the ultimate fantasy of the hip-pie handicraft artist.[177]

Caryl Bryer Fallert and her husband purchased a farm in 1974, and in 1978 went back to the land in earnest. They eventually grew and preserved their own food, and raised farm animals. Fallert eschewed the corporate world after deciding that corporate politics were not for her, working as a flight attendant while making quilts for her own pleasure and shunning the art marketplace. Images around the farm became very important in Fallert's studio quilts as she began to photograph feathers, plants, and other natural forms. Much of this imagery percolated in her imagination, coming to fruition years later in her quilts [Fig. 37].

Fig. 37. Caryl Bryer Fallert. *Feather Study #10* (detail, 1999). One of a series of quilts inspired by a feather, developed through hundreds of drawings.

Paula Nadelstern's "back-to-the-land" experience involved foreign travel because she spent a semester on a kibbutz in Israel—with the plan of eventually moving to a kibbutz. Although she loved Israeli folk dancing and Yemenite embroidery, Nadelstern learned that she hated farming and decided to attend collage. This decision took her to S.U.N.Y. at Old Westbury, with its 1960s "do-good ideologies," where she embroidered and crocheted "funky stuff" during political meetings and sit-ins. She also made her first quilt there, ripping up old clothes and assembling them into ten-inch squares for a one-patch construction.

Foreign Travel

This section appears under "Alternative Lifestyles" because foreign destinations exposed the traveler to different lifestyles, landscapes, and art, including fiber art. Molly Upton, for example, lived for a while with a family on the coast of Greece, an experience that provided imagery for

several quilts, including *Torrid Dwelling* and *Watchtower*, with their hints of hillside towns, castles, and ruins.[178] Italian hill towns appealed to Nancy Halpern during a trip in the early 1960s, a time when her avid interest in nature and architecture was beginning to flourish. Her quilts have always reflected her love of nature and natural materials, in architectonic structures.[179]

Trips to Africa have been inspirational for African-American artists Faith Ringgold, Carolyn Mazloomi, and Ed Johnetta Miller. Miller studied indigo dyeing in Nigeria; Mazloomi first traveled to Africa (Nairobi) in 1964 and remembers being astonished by the colors; and, Faith Ringgold has incorporated textile patterning from Africa into her paintings as well as her quilts [Fig. 38].

Fig. 38. Faith Ringgold. *Breakfast in Bed: The Windows of the Wedding Series #2* (1974, 65.5 x 27 in.), © Faith Ringgold 1974.

Caryl Bryer Fallert traveled to East Africa and parts of Europe during the 1970s, and has remarked that deep-rooted memories of these locales "often creep into [my] work in subtle ways that are not obvious to either me or the viewer at first glance." Terrie Hancock Mangat made several trips to Kenya, the first in the early 1970s. The giraffe fabric in her 1979 Quilt National work was purchased during one of these trips. Tafi Brown's earliest foreign travel was related to light, an appropriate theme since her quilt art is photographic. She was near the coast of West Africa to view the total solar eclipse of 1972.

Patricia Malarcher's "awareness of textiles" was expanded during travel in Mexico, Ecuador, and Indonesia, and she was struck by the ways that women integrated the making of textiles into their daily lives. In Bali, she was "enthralled by the lush colors and textures … and the ubiquity of textiles." In 1969 Nancy Crow saw a gallery show of lithographs by a woman artist in Porto Alegre, Brazil, and was struck by the extraordinary colors [Fig. 39]. She made her first quilt while living in Brazil, a bed quilt for her son.

Fig. 39. Nancy Crow. *Whirligig* (1975, 92 x 72 in.). This was the artist's first use in quilts of the bright colors she favored in her weaving, incorporating a striped fabric to create the energy of a whirligig. Like several artists in this book, Crow photographed her early quilts outdoors, hung against a building. Professional-quality photography to document quilt art gradually became the norm during the 1980s. (Some of the images published here are much later photographs of early work.)

Ed Larson traveled parts of the world between 1950-1955 while serving in the U.S. Navy. His exposure to art began when he saw different types of Asian woodblock prints in Korea, such as reproductions of Hokusai's work, and the works in Paris museums. Arturo Alonzo Sandoval also was exposed to Eastern art during his military service, visiting museums in the Philippines, Hong Kong, and Japan. Eastern art—such as Indian miniatures and Japanese woodblock prints—has been important for David Hornung, and he had his "first heavy dose" while visiting European museums in the early 1970s. He "has always been drawn to stylized renderings of natural objects that evoke a dual perception of image as both fact and referent or signifier."

India provided visual stimulation for Joan Lintault, Jill Le Croissette, and Jinny Beyer. Le Croissette, an Australian who became a U.S. citizen in 1967, traveled to India in 1969. She became interested in batik and Indian silks, and subsequently took studio classes in weaving and surface design at California State University in Los Angeles. Lintault lived in India from 1979 to 1980, doing research in textile craft processes. Beyer states that "probably the two most influential aspects of Nepal and India that influenced my quilting were, first, the colors—colors of saris, the Rajasthani colorful garments of both men and women, and the colors of the hand block-printed fabrics. The second was the borders that adorned everything—windows, doors, saris, buildings, roofs of trucks, elephant harnesses—anywhere you looked there were borders, so much so that I wanted to incorporate borders in my work." [180]

Asian textiles also influenced Sas Colby and Helen Bitar. A trip to Thailand in 1975 introduced Colby to Thai silks, which became her "palette" for a number of years. Bitar loved the "satiny" fabrics that she purchased while living in Korea and later used them in quiltmaking. Marie Lyman "found in Japan [1980] a validation of personal aesthetic concerns which were not encouraged in the West. This Japanese influence on Lyman's work is seen primarily in her subtle palette, the fine detailing of her surfaces, and in her choice of materials—primarily Japanese paper, old and new Japanese fabrics, and silk thread." [181]

Joan Schulze visited London in 1977, staying with her mentor Constance Howard, an expert needle worker with thorough knowledge of the local embroidery and textile collections. Schulze returned home with a new understanding of the English traditions: "manor houses filled with beautiful handwork, tapestries, weavings." Scandinavian design impressed Jeanne Williamson when her family took her to Sweden for three weeks in 1968, and she has felt a subtle influence on her work from that foreign experience. Nancy Erickson traveled in Germany and the British Isles, being particularly impressed by Scotland: "The landscapes in Scotland seep through in my paintings now and then, the feeling of desolation and loneliness was overwhelming to me."

Katherine Westphal is probably the most extensively traveled artist of any in the present book. Before 1980, she had been to Mexico, Europe, Greece, Egypt, Tunisia, Iran, Afghanistan, India, China, Japan, and Indonesia. During the trip to Mexico (in 1943, on a fellowship), she met David Siqueiros and Diego Rivera. Many of her travels have been adventures, and most of them have inspired imagery and patterning in her quilt art, embroidery, and collages [Fig. 40].

Fig. 40. Katherine Westphal. *Triennale* (1964).

144 Portions of the text in this chapter were first published in "My mother was not a quil-
 ter," in *Jean Ray Laury: A Life By Design* (San Jose: San Jose Museum of Quilts & Textiles,
 2006), pp. 4-5 (catalogue of Laury's solo show); in "Origins of American Art Quilts:
 Politics and Technology," *Proceedings of the Textile History Forum 2007*, pp. 5-13; in "Exotic
 Influences in Early Quilt Art," *Quilters Newsletter* 415 (April/May 2010), pp. 30-33; and,
 in *WOMANHOUSE: Cradle of Feminist Art, January 30 — February 28, 1972*. In the Art Spaces
 Archive Project: http://as-ap.org/sider/resources.cfm.

145 Most of the information in this chapter is taken from the narratives in artists' surveys and
 in interviews conducted by the author. The surveys are not footnoted.

146 Kyra E. Hicks, *Black Threads: An African American Quilting Sourcebook* (Jefferson, NC, and
 London: McFarland & Company, 2003), p. 217.

147 *Gee's Bend: The Women and Their Quilts* (Atlanta: Tinwood Books, in association with the
 Museum of Fine Arts, Houston, 2002), p. 399.

148 Faith Ringgold, "Preface," in Carolyn Mazloomi, *Spirits of the Cloth: Contemporary African
 American Quilts* (New York: Clarkson Potter, 1998), p. 8.

149 Driskell, David C., "Foreword," in Lisa E. Farrington, *Faith Ringgold* (San Francisco:
 Pomegranate, 2004), p. v.

150 Elissa Auther, *String, Felt, Thread and the Hierarchy of Art and Craft in American Art, 1960-1980* (Minneapolis: University of Minnesota Press, 2010), p. 132.

151 Michael James, *The Quiltmaker's Handbook* (Mountain View, CA: Leone Publications, 1993 reprint), plate 18, titled "Mandala."

152 See http://www.turtlemoon.com/greenquilts/gqstatement.htm.

153 Robert Shaw, *The Art Quilt* (Southport, CT: Hugh Lauter Levin Associates, 1997), p. 33. Ann Sargent-Wooster wrote an independent study paper while a student in the early 1970s at Hunter College comparing the "language" of quilts and modern art. She received an A.

154 Jean Ray Laury, *Quilts & Coverlets: A Contemporary Approach* (New York: Van Nostrand Reinhold Company, 1970), p. 48.

155 Shie's art history teacher was Thalia Gouma-Petersen, who later would become Miriam Schapiro's biographer.

156 In a phone interview of November 9, 2004, Arlene Raven remarked that when she was a student in art history classes, Mary Cassatt was the only female artist whose work was included in the curriculum. While teaching at Cal Arts, Raven spent many hours in southern California looking through bookstores to collect books that included female artists.

157 Male artists involved with Cal Arts included John Baldessari, Eric Fischl, Allan Kaprow, and David Salle. The school had a well-connected board of trustees, including people involved with the film industry, and the head of the school was married to a member of the Disney family. There was plenty of money for new programs.

158 Linda Nochlin, "Foreword," in Thalia Gouma-Peterson, *Miriam Schapiro: Shaping the Fragments of Art and Life* (New York: Harry N. Abrams, 1999), p. 10 (quoting the original *Womanhouse* catalogue essay by Chicago and Schapiro).

159 Interview with Colin Eisler at the Institute of Fine Arts, New York, September 27, 2004.

160 Sandra Burton, "Bad-Dream House," *Time Magazine: Special Issue, The American Woman* (March 20, 1972), p. 77 (illustrating the *Shoe Closet*, *Womb Room*, and *Nurturant Kitchen*). This issue is quite valuable as a document of the women's movement, featuring articles on women and various subjects, such as law, medicine, and education. On the same page as the *Womanhouse* review is a "Situation Report" on women artists and architects. The bizarre juxtaposition of advertisements (probably placed months before the special issue was announced) and articles is notable. One page before the *Womanhouse* review, for example, a full-page cigarette ad depicts the macho Marlboro man on his horse.

161 William Wilson, "Lair of Female Creativity," *Los Angeles Times*, February 21, 1972.

162 Gouma-Peterson, op.cit., pp. 70-71.

163 Arlene Raven, *Crossing Over: Feminism and Art of Social Concern* (Ann Arbor and London: U.M.I. Research Press, 1988), p. 111.

164 Image of *Comfort Him* by Evelyn H. Hebner, *Quilters Newsletter Magazine* (January 1975), p. 3.

165 Laura Cottingham, *Seeing through the Seventies: Essays on Feminism and Art* (Amsterdam: G&B Arts International, 2000), p. 25.

166 See Esther R. Holderness, *Peasant Chic* (New York: Hawthorne Books, 1977).

167 Phone interview, October 10, 2007.

168 Ed Rossbach, "Ed Rossbach Says," *Craft Horizons* (June 1976), p. 23.

169 Barbara Rush with Lassie Wittman, *The Complete Book of Seminole Patchwork* (Seattle: Madrona Publishers, 1982), p. 1.

170 Rush and Wittman, op. cit., p. 115.

171 Kirstin Olsen, *Southwest By Southwest: Native American and Mexican Designs for Quilters* (New York: Sterling Publishing Company, 1991), p. 16.

172 Op. cit., p. 23.

173 Rush and Wittman, op. cit., p. 2.

174 A typical comment in the artists' surveys was: "I tried weed but preferred champagne."

175 Enid Nemy, "If Everyone Wears Patchwork, Summer Will Be a Crazy Quilt," *New York Times* (May 27, 1969), accessed online.

176 The store had a ready clientele because it was located across the street from the Vermont Country Store. Phone interview with Upton's mother Barbara Upton, April 10, 2008.

177 One of Joy Saville's most vivid memories of the mid-1960s was having Ken Kesey's psychedelic bus hit the wrought-iron staircase of her apartment building in California. "He and his entourage slept in his lawyer's apartment [in the building], leaving the children to sleep in the bus and to roam the area in the morning. It was quite a scene."

178 Phone interview with her mother Barbara Upton, April 10, 2008.

179 Halpern has "always felt particularly connected to Molly Upton" with her own quilts "having a dialogue with hers." Halpern's *Hilltown*, for example, is a response to *Torrid Dwelling*.

180 E-mail to the author, August 5, 2008.

181 Lou Cabeen, "Pattern of Thought: A Look at Ethnic Influences on the Creative Process," *Fiberarts* 17: 4 (Jan/Feb 1991), pp. 32-33.

CHAPTER 4:
QUILTS, CRAFT, AND ART

Quilts have long been recognized as outstanding representatives of folk art and fine craft, but only during the past century have some examples been recognized as "fine art," and that designation remains problematic—partly because the very definition of "art" has been in flux since the 1960s.[182] The goal of feminism during the 1970s was "to change the character of art,"[183] and studio quilts have successfully entered this transformed art arena. During the 1970s, a few quilt artists had begun to exhibit in galleries alongside "fine art." Molly Upton, for example, was exhibiting quilts in a Boston gallery that was showing works by Christo at the time.[184]

The present chapter begins by focusing on the early stages of quilts as art, chiefly from the quiltmakers' points of view, by discussing their formal education and other influences not treated elsewhere, including newly developed processes as well as folk art. We then analyze the phenomenon of quilts appearing in art, and end with an assessment of quilt aesthetics based on evidence of the 1960s and 1970s.

FORMAL EDUCATION AND OTHER INFLUENCES

Many of the quilt artists who rose to prominence by the end of the 1970s had been trained in art or craft schools, usually receiving the B.F.A. and/or M.F.A. degree, chiefly in painting, printmaking, and fibers. This section of Chapter Four discusses the impact of their education on quilt art. Even those without formal training in crafts or art learned to apply new processes in their work. Folk art and ethnic textiles inspired numerous quilt artists of the 1960s and 1970s; a discussion of that influence concludes this section.

Classes in Craft, Art, and Design

Marilyn Henrion studied art at the Cooper Union Art School in New York, graduating in 1952 with a major in graphic design. The program at that time emphasized formalism, which has been a continuous undercurrent in her quilt and other fiber art. Henrion was involved in the 1960s New York art scene, performing in Claes Oldenburg's "Happenings" and other artistic events, while continuing to paint. During the 1970s Henrion turned to fabric as her medium, deciding, "fiber art was a frontier whose serious artistic possibilities had yet to be fully explored."[185]

Katherine Westphal began drawing as a child and took art classes, then later completed an M.F.A. in painting at the University of California, Berkeley. Her initial creations in textile art

were for the clothing industry, eventually using her own samples of painted and printed fabric to construct quilts. Sas Colby took Saturday classes at the Massachusetts College of Art and studied art for two years at the Rhode Island School of Design. As a military wife she "did a lot of sewing" and continued to take classes in watercolor. After moving to Connecticut in 1966, Colby met Norma Minkowitz and others working in fiber art, and her interests in art and textiles merged. She had her first studio in 1968 and began creating quilts, banners, masks, and fantasy garments. Kathleen Sharp studied art history and studio art, including surface design, at colleges in Virginia. This initial exposure to art prompted her later enrollment in studio classes at the University of California, Santa Cruz. In the early 1980s she began to incorporate collage and pastels to enrich her primary medium, the quilt.

Terrie Hancock Mangat attended children's' art classes at the Cincinnati Art Academy, which gave her "a taste for Art." She majored in ceramics and printmaking at the University of Kentucky, winning an award as the most outstanding graduating senior in art. She also took textile courses (one in the Home Economics Department), and began work on a quilt (*The Shrine to the Beginning*, completed fifteen years later). Until the 1980s, Mangat's techniques were "fairly traditional, hand piecing, hand embroidery, … screen printing." Joan Lintault earned an M.F.A. from Southern Illinois University in 1962, and began her college teaching career with courses in fibers and textile design in 1973. Previously she had worked in sculptural ceramics, and this experience would later influence her three-dimensional quilts. Lintault synthesized her art education with her own research into natural and synthetic dyes between 1964 and 1974, then between 1975-1979 added photo-sensitive dyes and photography on cloth to her repertoire. For her B.A. at Rice University, Liz Axford double-majored in architecture and fine arts. Although her studies did not include any textile-related courses, Axford explains that the instructor in her freshman design class "taught me how to see."

Sue Benner graduated with a B.S. in molecular biology, but she recalls, "I was lacking a creative outlet. During my junior year I took an elective in art history. Wow! I started studying in the art library. Later I took a second semester of art history, then a surface design class and drawing class my senior year. I had to beg and finagle my way into these classes since I was a science major." The surface design class was her first exposure to Procion dyes (see below). Benner made batik and painted quilts during graduate school, and suddenly found that she "was self-employed as a fabric artist" instead of working as a medical illustrator. Judith Content enrolled in the art program at San Francisco State University: "I studied everything they offered there, from ceramics and sculpture, to painting and jewelry. With all that background, when I stumbled into the textiles program, it just felt right and I knew it…. I'm very grateful for the thorough training I had, but I am also glad it culminated with textiles."

Jane Burch Cochran studied art as an undergraduate, and then seriously began to study painting and drawing in night classes from 1966-1970 at the Cincinnati Art Academy. She worked on large, abstract canvases, sometimes painting over what she had done and using the same canvas again. More than anything else, Cochran learned to value "process over product," an attitude that has served her well in her studio quilts. Nancy Erickson earned her M.F.A. in painting in 1969 at the University of Montana. Her thesis advisor was Don Bunse (inventor of the collograph), in whose classes Erickson found her penchant for drawing. Caryl Bryer Fallert minored in studio art as an undergraduate, with a major in English and creative writing.

By 1971 she was creating "great big paintings that could make you dizzy, but usually with clean lines," the latter attribute becoming a salient feature of her quilt art [Fig. 41].

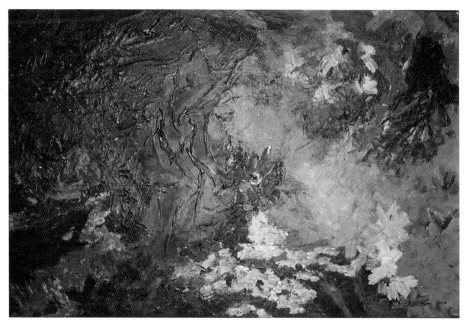

Fig. 41. Caryl Bryer Fallert. *Untitled Painting #1* (1971, 24 x 30 in.).

Rhoda Cohen began her art studies with oil painting in seminars at Radcliffe, mentored by Nathaniel Jacobson, a specialist in color theory [Fig. 42].

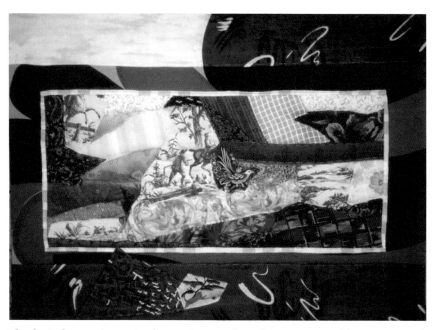

Fig. 42. Rhoda Cohen. *Blue Rider* (late 1970s). The title was inspired by a painting by Wassily Kandinsky, and by the "Blue Rider" group of artists in Germany during the early twentieth century, who contributed to the development of Expressionism.

Although she says that her knowledge of color is "a rock for me to stand on," a chance meeting with Nancy Halpern in the 1970s focused Cohen's attention toward quilt art [Fig. 43].

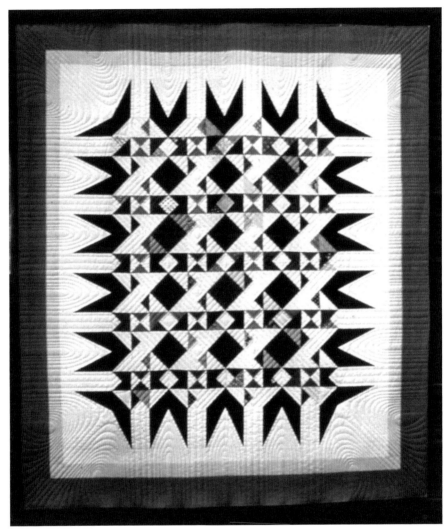

Fig. 43. Nancy Halpern. *Crow Quilt* (1976, 96 x 84 in.). This original design is based on Jeffrey Gutcheon's *Crow's Nest*, published in *The Quilt Design Workbook*. Halpern sees the black shapes in the border as crows swooping down onto a field; the Gutcheons visualized them as crows' feet.

Patricia Malarcher has an M.F.A. (1958) in painting from the Catholic University of America. Her most memorable professors were Alexander Giampietro, who taught ceramics, and Kenneth Noland, who taught a design course without any textbook. Malarcher began applying her knowledge of color and design to fabric after seeing an "exciting and joyous" exhibition of banners at the National Gallery of Art in the late 1950s.[186] For her 1972 M.F.A. in painting at Hunter College in New York, Ann Sargent-Wooster did Color Field poured paintings on unprimed canvas and created Conceptual Art using a grid system, two of her favorite teachers being Robert Morris and Agnes Martin. Conceptual Art incorporating textiles in printmaking has continued to be a pivotal aspect of her studio work.

Susan Shie studied art at the College of Wooster, and went on to earn an M.F.A. in painting at Kent State University. She explains, "I've never taken a quilt or surface design course. I saw myself as a painter, and I chose to paint on unstretched fabric in the late 1970s, which led me to sewing on it" [Figs. 44 and 45].

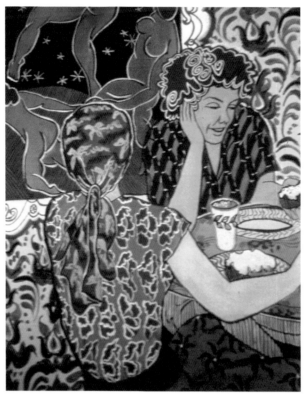

Fig. 44. Susan Shie. *Bagel Nach* (painting, detail, 1979). The painting on the wall was inspired by Matisse's painting *Dance*, which the artist had just studied at the Museum of Modern Art. Her later quilts would incorporate the sort of intense ornamental embellishment seen in *Bagel Nach*.

Fig. 45. Susan Shie & James Acord. *The Teapot/High Priestess: Card #2 in The Kitchen Tarot* (1998, 87 x 55 in.). Third quilt of The Kitchen Tarot project, with the first appearance of St. Quilta the Comforter (modeled after the artist's mother). This piece, which is intended to be interactive whenever it is displayed, contains twenty-eight pockets into which supplications can be inserted.

Robin Schwalb's association with textiles in an art context originated when she was a senior in high school in New York, thanks to an innovative teacher. She majored in studio art at the State University of New York in Binghamton, noting that "there was a strong anti-crafts bias at the school at that time—if you were interested in crafts, you tended to go up the road to Alfred University." After graduating from college, Jan Myers-Newbury took evening classes in studio art at the University of Minnesota, then in 1974 registered as a matriculated student, "floundering around in drawing and printmaking, trying to find my voice I stumbled (almost literally) into the Design Department ... (in the Home Economics College) and found my home and my way of working [Fig. 46]. Through a series of wonderful classes in color, design, and drawing, I began to do what I was 'meant' to do—work with fabric."

Fig. 46. Jan Myers-Newbury, *Fire and Ice* (1978, 96 x 92 in.).

Debra Lunn has been making quilts since 1964. While in graduate school studying textile design in 1976 at the University of Minnesota, she began hand-dyeing fabrics for use in her own quilts because there were few solid-color cottons available in fabric stores.[187] Lunn's quilt *Counterpoint*, the only piece in *Quilt National* 1979 made of hand-dyed fabrics, was designed on the school's mainframe computer [Fig. 47].

Fig. 47. Debra Lunn. *Counterpoint* (1979, 76 x 92 in.).

Her master's degree is in Textiles and Computer Art. Jean Ray Laury's 1956 M.A. at Stanford University was in design, which directly influenced her quilt art in that a quilt was part of her master's degree project.

Wendy Huhn majored in fibers for her B.F.A. in 1980 from the University of Oregon. The theme of her senior exhibition was "container as form." Huhn used basketry techniques with non-traditional materials, such as plastic tubing, ribbons, and strips of newspaper. Her interest in surface texture was easily translated into quilts. In the early 1970s Linda MacDonald began studying painting and weaving at San Francisco State University, earning her B.A. in 1978. By that time she had already decided that weaving was "not quite right" for her and was concentrating on making quilts, using her basic knowledge of design. Although Helen Bitar majored in printmaking at the University of Washington (where Jack Lenor Larsen also matriculated) because there was no Fiber Department, she remembers most vividly her weaving courses. One of the teachers in the department was Ed Rossbach, and her mentor was Richard Proctor. Bitar was encouraged to create textile art with bright, exuberant colors, resulting in her work being shown in a 1963 student exhibition at the Museum of Contemporary Crafts, *Emergent Student Craftsmen*. This early validation of her art led to a lifelong career in fiber.

The Art Students League in New York provided art training for several quilt and fabric artists. Nell Booker Sonnemann studied painting there with George Grosz and the Soyer brothers during the latter 1940s, and in 1959 earned her M.F.A. degree at Catholic University in Washington, D.C., where she remained to teach. "Fabric allowed Sonnemann to further pursue what compelled her as a painter. 'Space is what it's about,' she once said. 'It's not the subject, it's where you put the color and shape.'"[188] Michael Cummings flowered early as a child, copying the wallpaper designs on his grandmother's walls and learning to draw by the age of nine. Around 1975 he decided, "to get serious about his art" and began attending classes at the Art Students League, when he had a momentous meeting with Romare Bearden and began experimenting with collage. For an assignment, students were asked to sew a banner, and Cummings realized, "A banner was born from my humble efforts, and a light went on in my mind. Why not use fabric as a source to create my art, rather than collage?"

Ed Larson first studied art at the University of Oklahoma, then after serving in the U.S. Navy from 1950-55, enrolled in the Art Center School located at that time in downtown Los Angeles. Larson's classes in design and illustration provided a solid foundation for his pictorial quilts. Arturo Alonzo Sandoval has an M.F.A. in fiber sculpture from the Cranbrook Academy of Art, and has taught fiber art for many years. Working with fiber as an art medium came naturally because his family has a history of weaving, in the Spanish Colonial tradition. Sandoval's formal education gave him the impetus to experiment with materials and technique, resulting in his quilt art.

David Hornung, now chair of the History of Art Department at Adelphi University, earned his M.F.A. in painting at the University of Wisconsin, Madison. He made quilt art between 1978-1985, focusing on color, one of his academic strengths [Fig. 48]. "Though he builds his constructions of piecing and appliquéing, Hornung makes clear that his intent is metaphorical and his allegiance, to formalist concerns."[189]

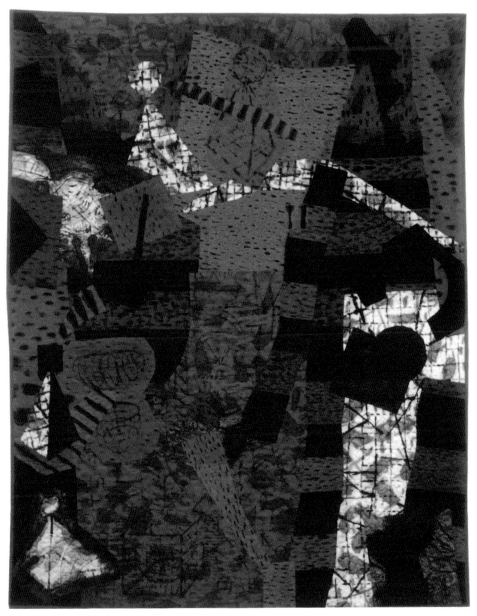

Fig. 48. David Hornung. *Red Construction* (1980, 72 x 60 in.).

Michael James holds B.F.A. and M.F.A. degrees in painting and printmaking, the latter from the Rochester Institute of Technology [Fig. 49]. At RIT James became acquainted with students and faculty members in The School for American Craftsmen, which had programs in fibers, metals, ceramics, etc. He acquired an understanding and appreciation of contemporary American crafts, and during the early 1970s he channeled his art training into the tactile appeal of fabric and quilts. From the very beginning, the quilts of Michael James have been distinguished by an emphasis on the expressive function of color, and on illusory space, in a very painterly mode.

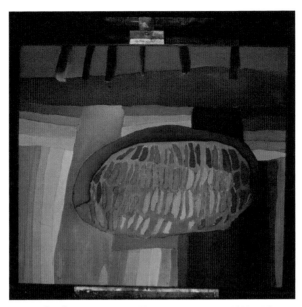

Fig. 49. Michael James. *Medallion* (painting, 1973, 42 x 48 in.).

Joyce Carey is among the weavers who became quilt artists. Carey studied weaving as an undergraduate, and earned her M.F.A. in 1976 at the University of Wisconsin, with Ruth Kao as her mentor. To Carey's expertise in technique, Kao contributed "an interest in what she called 'systems'—color interaction, movement of pattern into form, gradations of texture, size, or shape She pushed me into going deeper and expressing something of significance along with color and pattern." Carey's quilts from the 1970s often had a woven structure [Fig. 50].

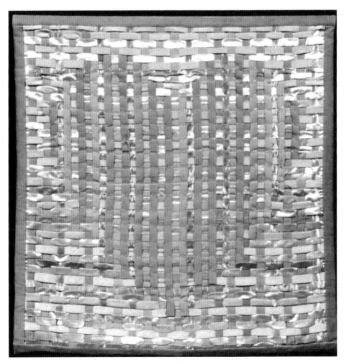

Fig. 50. Joyce Marquess Carey. *Closeup* (1976, 45 x 45 in.). This quilt was transitional in the artist's movement from weaving to quilts.

Nancy Crow earned an M.F.A. in ceramics and weaving at Ohio State University, but says that her focus was always ceramics. As an undergraduate, throwing on the wheel "honed down the positive/negative configuration" for her. Crow mentioned that the late 1960s witnessed the retirement of older professors in programs that had begun after World War II, with many departments "not so disciplined," including those offering studio classes. Tafi Brown earned her B.F.A. and M.F.A. degrees at Pratt Institute, specializing in ceramics, and did postgraduate work in ceramics at Alfred University. Brown's initial interest in photographic processes stemmed from a desire to apply photographs on ceramics, "and ended up learning how to make cyanotype prints … which was the beginning of my studio art quilting career!"

Bets Ramsey majored in art in college, earning a B.F.A., but wanted to focus on crafts in a graduate program at the University of Tennessee at Knoxville. Marian Heard had come from New York in the 1960s to participate in the Tennessee crafts revival, and Ramsey decided to study with her. Instead of an M.F.A., Ramsey earned an M.S. because crafts were taught in the Department of Home Economics at the university. She soon began to work with textiles in a painterly fashion.

Joy Saville has some interesting comments about not having any sort of formal training in art or design: "In hindsight, I perhaps missed out on the breadth and depth of an academic education, and I do not have a degree from an art school … nor am I privy to the resulting institutional network. At the same time, I need not give credits or allegiance to a particular school or theory and am free to chart my own course." Many quilt artists were in Saville's situation, especially by the end of the 1970s. They formed an eager audience for those who traveled around the country during the early 1980s teaching workshops in techniques and processes.

New Processes and New Images

During the 1960s, some of the schools teaching crafts, in which students could learn basic quiltmaking, had begun to include classes in techniques and processes—especially painting and printmaking—used in the world of the so-called fine arts, but which could be applied to fabric and quiltmaking. "The range of influences and sources that quilt artists draw upon is wide ranging and eclectic. As trained artists, they can bring their knowledge of the studio processes of printmaking, photography, and painting, as well as those of such related textile arts of weaving, dyeing, and embroidery, to bear on the problems encountered in their search for artistic expression."[190] In fact, some of the quilt art of the latter 1970s featured mixed media, with several influential artists working in surface design processes and techniques.

In her lecture at the 2008 College Art Association's annual conference, Patricia Malarcher spoke about surface design in quilt art: "In the 1960s, a climate of experimental freedom prompted artists to explore unconventional art materials. Many artists put down their paintbrushes, picked up fabric and thread, and began to sew art. Some later acknowledged that after an academic orientation to abstract expressionism, they were drawn toward the tangibility of materials."[191]

For some quilt artists, content became more important than material, style, or technique. As quilt artists struggled to introduce new political and aesthetic attitudes into their work, they looked to new tools, materials, and processes.[192] Although most commercial fabrics no longer satisfied the expanding creative vocabulary of many of these artists during the 1960s and 1970s, the craft textiles of these two decades spurred the textile industry to incorporate vibrant new designs that, in turn, appealed to quilt artists.

Several textile designers who established their businesses during this period provided innovative material eagerly used by those working in the quilt medium. Jack Lenor Larsen's studio was among the most provocative and influential of those in the United States. As artists and designers during the 1970s became aware of textile culture as a valid phenomenon, they made textiles "not only the substance but also the subject of their work."[193] By the 1980s, the industry as a whole had begun "to recognize the potential of craft and the independent designer-makers as a means of sophisticating their products."[194] This sophistication resulted in much greater variety in both colors and patterns of textiles, to the delight of quilt artists.

World War II stimulated the invention of new industrial tools and materials in this country during the late 1930s and early 1940s, a process continued by the space race of the 1950s. If we had to choose one single tool that contributed most to the development of studio quilts that featured images during the '60s and '70s, it probably would be the photocopier. Wendy Huhn, for example, says that the photocopier saved her in an art class in which her drawings did not adhere to the professor's high standards. She later began incorporating photocopied images into her work with fabric, and continues to do so today. Bets Ramsey and Arturo Alonzo Sandoval are among the other quilt artists who were using the photocopier during the 1970s to create image transfers.

Katherine Westphal was a pioneer in the first wave of contemporary quilt artists who learned to manipulate images with the photocopier, as reported by her husband Ed Rossbach: "Several identical copies can be made. These may be combined to repeat images, sometimes in shattered form. This fascinates her. Then the pasted pieces can be put back into the copier and reintegrated as one piece of paper.... I watch her take cloth and patch it or put layer on layer and then integrate the whole assemblage into one textile by quilting and other means.... The way Katherine sees it, the color Xerox is not a copy, but a new creation."[195]

Until the mid-1970s, quilt artists learned about using fabric in photocopiers via word of mouth and in workshops. But in 1978, a comprehensive handbook was published by a group of artists that explained how graphic artists could achieve some amazing effects. *COPYART: The First Complete Guide to the Copy Machine* included information on collage, heat transfer, cyanotype, and other processes and techniques that were being used in quilts.[196] Also in 1978, Joan Lintault presented a paper at the National Surface Design Conference concerning "Xerox Transfers on Cloth."

For cyanotype prints, which usually were produced with a contact process using photographic images, quilt artists no longer had to pay for expensive, large-format, high-contrast negatives. All they had to do was to slap a high-contrast photograph on the copier, then print the image onto an eight-by-ten-inch sheet of clear plastic. (If they were lucky, the plastic did not jam and melt in the machine.)

Stencils for photo silk-screening could also be created in the copy machine, and screen-printing was becoming a popular method of applying imagery to fabric in the '60s and '70s [Fig. 51].

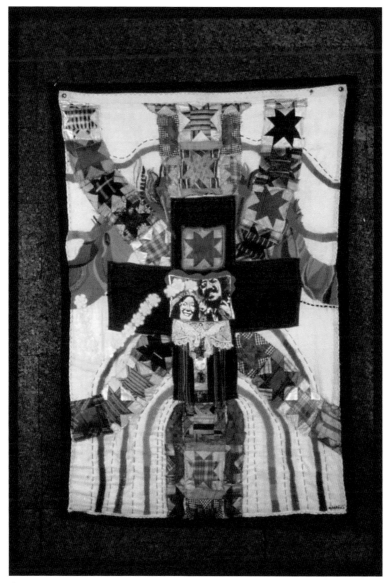

Fig. 51. Marilyn Pappas. *The Red Cross Quilt* (1973, 68 x 46 in.). Image of a young couple on their wedding day, antique quilt blocks, vintage Red Cross flag.

One of the pioneering quilt artists using this process was Wenda von Weise, who had a large photographic piece in the 1979 *Quilt National* exhibition. Another screen-printed quilt by von Weise had been selected for the 1976 exhibition at the Museum of Contemporary Crafts. She usually worked with multiple images in a loose grid structure, similar to the screen prints of Andy Warhol.

New processes in printmaking enabled quilt artists to personalize their imagery with everyday materials, such as cardboard. The collograph first made its appearance in the 1960s, when polymer glues allowed artists to assemble collages that could be permanently fastened together, then adhered to bases made of Masonite. These plates, which are slightly sculptural, can be printed on fabric in a simple roller press. The resulting fabric prints are very painterly. New York quilt artist Karen Berkenfeld was a master of collograph printing on fabric.

Quilt artists in home studios could successfully print on fabric because new dyes and fabric paints facilitated this process. Acrylic polymer in emulsion began to be added to paint in 1960s—you may know this type of paint under its later names, such as Createx, Versatex, and Liquitex. Artists found that paint could be screened, brushed, or stamped directly onto fabric, and the painted surface remained relatively flexible. More importantly, the fabric could be stitched by machine or hand. Therese May benefited from this technology at the beginning of the 1980s, discovering that she could make a quilt and paint on it. As she says, "This was a wonderful revelation and helped to integrate the work."

The invention of Procion MX dyes in the 1950s revolutionized the coloring of fabric. This fiber-reactive dye and others like it bond with the fabric, maintaining the original texture. Artists no longer had to have their work steamed to set the dye because water from the studio faucet would suffice. This ease of operation allowed many more people to work with fabric dye, with some very innovative results. Gayle Fraas and Duncan Slade pioneered the use of paintbrushes with dyes, producing studio quilts with realistic imagery and some astonishing *trompe-l'oeil* effects in the late 1970s.

As a college student at San Francisco State University, Judith Content studied surface design with Candace Crockett and Ana Lisa Hedstrom. She became enamored with pole-wrapped silk, experimenting with broom handles, apple juice bottles, and wine bottles, "finding her own way" into quilts as an art medium. Procion dyes were also important for Jan Myers-Newbury, especially in her first eight years of quiltmaking. The tonal effects she created with her geometric compositions could be precisely controlled during the dyeing process. Joan Schulze dyed some of her fabrics during the 1970s and created batik landscapes. Color has always been a crucial element of Schulze's work, and Procion dyes made it easy to experiment with color on fabric.

Modern-age materials also contributed to the innovative aspects of American quilt art, for example Patricia's Malarcher's transformation of Mylar. In the late 1970s, she attended a workshop and critique session conducted by Walter Nottingham. Malarcher showed slides of her early Mylar quilts, along with images of her baskets. She recalls that craftspeople tended to think that her work was too slick, but then he noticed "how magically light bounced off it in a darkened room" and encouraged her to follow her instincts.

Folk Art[197]

Paul Smith has mentioned affinities between contemporary fabric collage and folk art, indicating that fiber art can function as a bridge between the art world and folk art.[198] Innovations in fiber art of the 1960s and 1970s spearheaded "a strong interest in ancient or ethnic textile cultures."[199]

Folk art of various types has influenced quilt artists, but the overwhelming influence has been from quilts themselves, including Amish, African-American, American, and Victorian examples. Some of today's quilt artists began making quilts by using traditional folk-art quilt patterns, such as Nancy Erickson (Grandmother's Flower Garden), Marilyn Henrion (Dresden Plate), Michael James (Drunkard's Path), and Paula Nadelstern (Log Cabin), but their own sense of aesthetics eventually led these artists into more original explorations of the quiltmaking medium.

Antique Amish quilts, with their bold, broad applications of solid color, strongly impressed several quilt artists during a crucial formative period of their careers. The Whitney Museum's 1971 quilt exhibition, which included Amish examples, had a major impact (see Chapter Two). Seeing that exhibition or its catalogue was a revelation to many viewers, such as Marilyn Henrion—who until that experience had been a painter. Struck by the resonance of color in quilted cloth, Henrion decided to turn her hand to fabric. She and others have incorporated bright color combinations and the tight texture of Amish quilting into their own pieced and appliquéd compositions.

African-American quilts, beginning with the nineteenth-century example of Harriet Powers's narrative biblical quilts, have been especially significant for contemporary quilt artists who wish to loosen the design and let their creativity flow. This "loosening" in general has been credited by several artists as leading to enhanced creativity, e.g., Nancy Crow: "I am drawing my patterns so they are very 'loose,' which will leave me lots of room for experimentation."[200]

African-American vintage folk-art quilts have been important sources of motifs and content for African-American artists [Fig. 52].

Fig. 52. Carolyn Mazloomi. Untitled quilt (detail, 1981-82).

Carolyn Mazloomi's 1998 book *Spirits of the Cloth* documents numerous examples. But quilt artists from other backgrounds have also turned to these quilts for inspiration. Liz Axford, for example, long ago appreciated the originality of flamboyant strip quilts by Anna Williams.

Bonnie Peterson is among the quilt artists inspired by the intricate assemblage techniques of Victorian quiltmakers. The political messages in Peterson's quilts are often delivered through an ironically pretty surface, with her text encoded in delicate embroidery. Many of the Victorian women who created crazy quilts could be considered as living within a special category of folk-art community, sheltered from the larger world socially instead of geographically, working silently yet determinedly. This special aspect of female silence or isolation, about which Radka Donnell has written and lectured, has significant ramifications for all art historically produced by women.

Other folk-art fiber art has served as sources for contemporary quilt artists. The visual structure of Early American hooked and braided rugs appears in quilts made by Therese May. Originally, May incorporated the patterns of folk-art rugs into her paintings and drawings. Then, around 1980, this technique developed into the painted quilt, her most self-assured expression. Folk-art embroidery also has inspired quilt artists (see Chapter Three). In Susan Shie's quilts, the colors of heavily embroidered surfaces are often activated and enlivened by "stitches" drawn in acrylic paint.

The folk-art traditions of other cultures and geographic areas have been instrumental for quilt artists, notably textiles and artifacts from Africa, Mexico, and Central and South America (see Chapter Three). While many of the motifs in the folk art of these areas—such as striped and checkerboard designs—are full of symbolic meaning for the communities in which they are produced, to North American eyes they are largely ornamental. Quilt artists have used these designs and patterns as their own, for pure decoration. Yvonne Porcella, for example, "contemporized" striped fabrics in her earliest quilt art. In Porcella's quilts, the narrow striped segments in black and white serve to anchor and emphasize colored shapes [Fig. 53].

Fig. 53. Yvonne Porcella. *Black, White, Red All Over* (kimono, 1979). The artist's first attempt at strip piecing, with the diamonds appliquéd by hand, was inspired by an illustration of an antique kimono.

Jane Burch Cochran has been inspired by Mexican folk art, which she believes is filled with the soul of its creator. But the spirit in her own quilts is that of an artist trained in drawing and painting, whose particular obsessions and enthusiasms are formally interpreted through the embellished surfaces for which she has become well known.

The iconographic content of folk-art paintings and drawings by artists such as Edward Hicks and Howard Finster have appealed to quilt artists. Nancy Erickson, for example, has been attracted to Edward Hicks's various interpretations of the "Peaceable Kingdom." The wild animals painted in her quilts have communicated a similar desire for peace on earth, or at least an amicable coexistence. But unlike the tranquil scenes in Hicks's paintings, Erickson's quilts have the added twist of her wicked sense of humor, making their aesthetic appeal much more interesting to modern viewers. Ed Larson became acquainted with American folk art during the late 1950s when he was living in Philadelphia. The heroic subjects of his early quilts were oversized, composed with the hierarchy of scale often found in folk-art paintings and other media. Larson's use of continuous narrative and symbolic associations, with more than one part of the story depicted on the same surface, was also influenced by folk art. Some of the early quilts by Terrie Hancock Mangat are also in this vein.

In the initial creative impulse, folk art and fine art often begin on common ground. Their aesthetic differentiation occurs as a piece is produced and decisions are made concerning form and content. The modern world offers a limitless source of information and imagery, as well as academic knowledge and training. Folk artists historically have had fewer choices to make and have been more limited in available tools and materials. Quilt artists of the 1960s and 1970s were on the threshold of an explosion of possibilities.

CRAFTS AND ART

The 1960s and 1970s witnessed a broadly cross-medium juxtaposition and mingling of materials, as can be seen in the exhibitions discussed in Chapter Two. The historical divisions between "craft" and "art" began to break down, pertaining to subject as well as object. Jackson Woolley, an enamel artist, remarked in 1960, "The division between so-called 'fine arts' and so-called 'useful arts' has been diminishing quite naturally as the craftsman concentrates more on decorative, rather than useful objects, and in turn, the fine arts use craft materials and craft methods."[201] Fiber entered the art world from diverse directions, even though its hierarchical status in the art market remained subservient to the arts in general.[202] Artists became attuned to "that sense of accumulated energy that is the special mark of textiles."[203]

Quilts in Art

Robert Rauschenberg's famous combine *Bed* (1955) incorporates an actual Log Cabin quilt,[204] an example of the artist's vast and courageous experimentation with materials. John Russell wrote, "How people hated 'Bed.'" … It was a painting, it was a sculpture, it was a *thing*. In 1958, it could not even be shown at the summer festival in Spoleto, Italy, so offensive was it to Italian sensibilities …. The painted areas are … an elegy for Abstract Expressionism …. The

checkerboard [actually not a 'checkerboard'] quilt is a critique of the 'Homage to the Square' of Josef Albers, whose pupil Mr. Rauschenberg had been at Black Mountain College." [205] Interestingly, the quilt could not be taken for what it is by an art critic, but had to function outside its "thingness."

Quilts in art were something of a phenomenon during the 1960s and 1970s, extending to purposeful play between quilts and paintings. In 1978, an arts center in Alaska mounted an exhibition in which Therese May had a quilt titled *Lamp Quilt*, with Katherine Huffaker's oil painting of the quilt hung next to it. Complementing this diptych was a second quilt by May picturing Huffaker painting the first quilt. The presentation caused viewers to reconsider their assumptions about the inherent qualities of materials. In 1980, Margaret Harrison exhibited several textile objects in *Craftwork*, in a conceptual mode similar to that of Joseph Kosuth. For each object, she exhibited both a photograph and a painting, in the same scale as the actual object. One of the pieces was a section from a Log Cabin quilt, with a play on contrast and texture among the three formats. [206]

Other artists were painting images of quilts in oils or acrylics. In the examples below we are not even considering the many grid-like and pattern paintings of the 1970s that resembled quilts. In 1974, Idelle Weber painted *Quilt*, a 45-inch high surface depicting an antique quilt with two corners tied into a large knot in the center of the composition. [207] Unlike other images of quilts, this hyper realistic painting emphasized and exaggerated the potential volumetric aspects of quilts as wrappings or coverings. In 1975 Hassel Smith exhibited his *A 1-2-3-4-1 painting (quilt pattern)*, nearly 68 inches square, at the David Stuart Galleries. This hard-edged geometric composition with elements arranged in rhythmic intervals somewhat resembles a pieced quilt, an association verified by the title. [208] Ronald Markman exhibited his 60-inch-high painting *Quilt* in 1977 at the Terry Dintenfass Gallery, with the composition loosely based on Log Cabin squares. [209] He embedded narrative in the strips with cartoonish images in small-scale, humorous themes contrasting with the "quilt's" sedate structure.

The pattern and decoration movement, in which Miriam Schapiro and Joyce Kozloff played important roles (see Chapter Three), encouraged the intrusion of quilt-like forms and textiles into art. Cynthia Carlson was on the fringes of that movement. Because she often worked with grids, many of Carlson's paintings resonated with quilts. Her 1976 painting *Short Job* (60 inches high) was shown in 1976 in her solo show at Hundred Acres. Reviewing the show, Jay Gorney described the painting: "Perhaps her most successful recent work, [it] fully explores the possibilities of Carlson's new palette. The canvas is divided into separate squares of grayed colors which are connected by stitch-like strokes, producing an overall effect much like that of a patchwork quilt.... *Short Job*, rich in humor and allusion, is a compelling synthesis of disjointed reality and folk art, executed in Carlson's thick, layered paint." [210] Each of the 36 rectangles contains another "stitched" rectangle, which in turn contains a painted image or shape. The thick paint in the inner rectangles contrasts with the more delicate texture of the "stitching," producing a dissonance between form and content.

Romare Bearden and Lucas Samaras both used patchwork to build their surfaces. In his reviews of their work in the *New York Times*, Hilton Kramer succinctly explained these processes. Concerning Bearden, he wrote: "The style that serves this very personal iconography might best be described as patchwork Cubism ... Actual quilts, too, are depicted in appropriate

settings.... The patchwork quilt is, after all, a kind of primitive Cubism in itself, and its use allows the artist both a free play on personal memory and the discipline necessary for art."[211] Kramer was astonished when Samaras produced his sewn surfaces: "With the new work that Mr. Samaras is now showing under the title of 'Reconstructions,' ... what really shocks is that the abstract pictures are not actually paintings at all but patchwork fabric constructions sewn on a sewing machine. The vogue of the patchwork quilt in recent years must have suggested to many artists and art students that there was something to this old folk art for the modern artist to take hold of and bend to a new purpose, but Mr. Samaras seems to be the only one around to have actually acted on the idea."[212]

Artist's Quilts: Quilts by Ten Contemporary Artists in Collaboration with Ludy Strauss began in 1974 in a conversation between quilt collector Ludy Strauss and California artist Peter Alexander.[213] The project, which consisted of having artists design quilts that were then executed by "expert quilters" for the artists' personal use, took six years to complete.[214] Not surprisingly, "expert quilters who were willing to work on other than traditional designs were difficult to find."[215] Although planned with the best of intentions, the project skewed the aesthetic power of contemporary quilt art. Most of the works in the collection might just as well have been paintings or prints. They gained little from having been transformed into quilts. Nevertheless, as a result of the collaborations, several of the artists "incorporated the quilt form into their body of work."[216]

The Artist & The Quilt explicitly positioned quilts in art, but in the same strained manner as the Strauss project. The concept behind *The Artist & The Quilt* was to commemorate 1975, the International Year of the Woman, "by asking prominent women artists to design quilts. There was a certain irony to our idea. Nothing has been more crucial to the radical changes in the art of this century than the eagerness of artists to experiment with new media ... in order to expand the definition of what art comprises. Yet 'new' in this case meant a form of art practiced by women for four hundred years and, for the most part, reserved exclusively for them. We were considering a return to a truly indigenous art form in order to celebrate a contemporary phenomenon: the women's movement."[217] The catalogue features essays by Lucy Lippard and Miriam Schapiro; the designing artists included Lynda Benglis, Mary Beth Edelson, Harmony Hammond, Joyce Kozloff, Alice Neel, Faith Ringgold (a collaboration between Ringgold and her quilter mother), Betye Saar, and Miriam Schapiro (who worked on the construction of her design).

The catalogue publishes short biographies of the "artists" and then the "quilters," a division that occasioned negative comments from the critics. In fact, nearly half of the "quilters" were artists in their own right, several having had gallery recognition as quilt artists, and the others coming to prominence during the late 1970s and early 1980s—e.g., Judy Mathieson, Sharon McKain, Bonnie Persinger, and Wenda von Weise. The catalogue and exhibition for touring were not ready until 1983, by which time quilt art had become somewhat politicized as a result of the women's movement that the project was meant to celebrate.

In her catalogue essay, Lucy Lippard remarked that the project guided "'high artists' (those acknowledged in the art world) into collaboration and 'low culture,' ... guiding craftspeople (though not all the women who did the quilting here see themselves that way) into collaboration and 'high culture.'"[218] The problem in the early 1980s was that some quilt

artists had already arrived at "high culture" on their own, and others had little use for the art world, being firmly rooted in the hybrid state of quilt artists, bridging the worlds of crafts and art—some quite successfully. Critics in the art world had virtually no knowledge of this activity.

Reviewing the catalogue, Al Paca in *Fiberarts Magazine* was ruthless: "Have these women ever looked out there in the real world to see what's really happening with the art of the quilt? There are already a helluva lot of mighty fine artists creating gorgeous quilts without their benevolence. This whole project patronizes and denigrates the real artists who create quilted art works."[219]

Quilt Aesthetics

Jean Ray Laury's first published article, and the one she considers most important, appeared in *House Beautiful* in January 1960: "The Simplest Possible Creative Stitchery."[220] The opening paragraph listed three traits needed for creativity—enthusiasm, patience, and inventiveness—which Laury still encourages in her workshops. This article, written long before computerized sewing machines with their myriad stitches were available, cautioned against too much dependence on the machine: "Be sure whether you or the machine has the final word in determining the appearance of your work" (p. 107). Her focus on the artist's eye and hand was paramount. In Laury's 1966 book *Applique Stitchery*, she advocated a judicious balance between materials and technique, without the sort of obsession that can overtake artists immersed in materiality. Throughout the book, she emphasized in subtle ways the importance of following through with an idea or emotion.

Quilt art of the 1960s and 1970s generally fell into two categories: quilts with patterns in blocks or strips (often from templates of the artist's own making) and quilts with a more free-form structure, utilizing appliqué or asymmetrical piecing along with dye, paint, and embellishment. Both styles had affinities with collage and assemblage, analyzed in detail by Museum of Modern Art curator William Seitz in his 1961 *Art of Assemblage* catalogue. Both approaches to quilt art offered the possibility of accidental design, and they differed from the rigidity of traditional quiltmaking in that their "ultimate configurations are so often less predetermined."[221] Several artists interviewed for the present book have explained this process, how serendipitous or even "incorrect" arrangements of blocks or experimental insertions of color led to dynamic, unusual results. The freedom inherent in the composition of most studio quilts from the 1960s and 1970s could be seen as a metaphor for this very American art form, in which few rules applied.

Hilton Kramer's *New York Times* review of the 1971 Whitney exhibition *Abstract Design in American Quilts* (see Chapter Two) focused on "the native genius for visual expression" illustrated by antique quilts in the show. He went on to say, "In many quarters the suspicion persists that the most authentic visual articulation of the American imagination in the last century is to be found in the so-called 'minor' arts—especially in the visual crafts that had their origins in the workaday functions of regional life."[222] "Functions" is a key term here, for it is questionable whether some of the quilts in the show, which evidently were in pristine condition, had

ever been used to any extent. They actually may have been created purely as objects of visual delight, the best examples featuring original designs.

In his introduction to the *Objects : USA* catalogue, Lee Nordness wrote, "Should nonfunctional objects alone be candidates for fine art? An obvious challenge arises for the person working within a functional expression: the more functional an object is the more difficult for its presence to overshadow its function."[223] In his opinion, those who create production work or commissions dictated by the marketplace lose "the spark that occurs in an artist deeply immersed in his medium. Passion is one of the most salient ingredients of art: it will not flow or spark on demand or for reward."[224]

Passion was perhaps *the* driving force in quilt art of the two decades discussed in the present book. Those committed to creating quilts as art during this period had little expectation of material reward—only the reward of working with the materials at hand, and the satisfaction of being part of the historical continuum of American quilts. Beyond all else, quilt artists of the 1960s and 1970s were makers, exhilarated by the texture, color, and physicality of fabric. "By the end of the 1960s, winds of change were blowing. / What began quietly in the 1960s would grow into a major movement in the 1970s, morphing in ways that no one could have predicted and taking quilts to places no one could have imagined."[225]

182 One of the earliest published references to quilts as an art form is "Quilts as Art," *Newsweek* 22 (August 2, 1943), p. 91, a review of an exhibition of original, quirky quilts by Bertha Stenge.

183 Lucy Lippard, "Sweeping Exchanges: The Contribution of Feminism to the Art of the 1970s," *Art Journal* 40 (Autumn-Winter 1980), p. 362.

184 Phone interview with her mother Barbara Upton, April 10, 2008.

185 Ed McCormack, "Marilyn Henrion: A New Music of the Rectangles and Spheres," in *Marilyn Henrion: Noise* [New York: published by the artist, 2007], p. [4].

186 "The banners were by students from Immaculate Heart College in Los Angeles, which was known for its innovative approach to materials—Sister Corita (later known as Corita Kent) the printmaker was on the faculty. The colorful, freely shaped banners were installed in open space in conjunction with an exhibition of floor-to-ceiling black and white photographs of contemporary architecture that blended into the marble walls....When I saw them I was a graduate student in painting and immediately wanted to work in fabric. I didn't know until later that Nell [Booker Sonnemann] had also seen the show and that it inspired her to start making appliqué hangings." E-mail to the author, March 28, 2010.

187 Later she founded Lunn Fabrics, the first U.S. company making hand-dyed fabric gradations for quiltmakers.

188 Patricia Malarcher, "Nell Battle Booker Sonnemann," in *Nell Battle Booker Sonnemann* ([Greenville, NC: East Carolina University, 2007]), p. 5.

189 Michael James, "Beyond Tradition: The Art of the Studio Quilt," *American Craft* (February/March 1985), p. 20.

190 Robert Shaw, *The Art Quilt* (Southport, CT: Hugh Lauter Levin Associates, 1997), pp. 21-22.

191 The author graciously shared her unpublished text with me.

192 See Robert Shaw, *The Art Quilt*. Southport, CT: Hugh Lauter Levin Associates, 1997, pp. 117-128.

193 Chloë Colchester, *The New Textiles: Trends and Traditions* (New York: Rizzoli, 1991, p. 8.

194 Op. cit., p. 9.

195 Ed Rossbach, "Ed Rossbach Says," *Craft Horizons* (June 1976), p. 80.

196 Heartfelt thanks to Wendy Huhn for sending me information abut this book.

197 Portions of this section were first published in "Folk-Art Aesthetics and American Art Quilts," *Fiberarts Magazine* (Nov/Dec 2003), pp. 32-36.

198 Paul Smith, *Fabric Collage* (New York: Museum of Contemporary Crafts [1965]), p. (5).

199 Elissa Auther, "Classification and Its Consequences: The Case of 'Fiber Art,'" *American Art* 16 (Autumn 2002), p. 5.

200 Letter to Michael James, May 23, 1978.

201 Jackson Woolley, in "What Criteria for the Crafts," *Crafts Horizon* 20 (March/April 1960), p. 38

202 Elissa Auther, *String, Felt, Thread and the Hierarchy of Art and Craft in American Art, 1961-1979* (Minneapolis: University of Minnesota Press, forthcoming 2009), p. 12. This book will offer "the first broad account of the ubiquitous but largely overlooked use of fiber across the American art world in the late 1960s and 1970s." I am extremely grateful to Elissa Auther for her generosity in sharing this text with me.

203 Betty Park, The Woven Collages of Arturo Sandoval," *Fiberarts Magazine* (Sept/Oct 1979), p. 72.

204 The quilt is now badly faded, in comparison with the fresh colors of its condition in 1955. For many years the piece has been at the Museum of Modern Art in New York. Evidently its textile components were not taken into consideration by the institution during display or storage.

205 John Russell, "Art that Sings: A Rauschenberg Retrospective," *The New York Times* (March 25, 1977), accessed online in the newspaper's archives [exhibition review]. It seems much more likely that the quilt reminded Rauschenberg of the patchwork sewn by his mother when he was a boy in Texas, thus making *Bed* an even more personal statement.

206 Illustrated in Charlotte Robinson, ed. *The Artist and the Quilt* (New York: Knopf, 1983), p. 42.

207 Illustrated in *Arts Magazine* 50 (September 1975), p. 21. The painting was in the artist's exhibition treating the theme of New York garbage at Hundred Acres gallery.

208 Illustrated in *Art News* 74 (December 1975), p. 87, in Thomas Albright's review of Smith's retrospective exhibition at the San Francisco Museum of Art.

209 Illustrated in *Arts Magazine* 51 (February 1977), p. 32.

210 Jay Gorney, "Cynthia Carlson," *Arts Magazine* 51 (October 1976), p. 13, illustrating the painting.

211 Hilton Kramer, "Bearden's 'Patchwork Cubism'," *The New York Times* (December 3, 1978), accessed online in the newspaper's archives.

212 Hilton Kramer, "The Daring Theatricality of Lucas Samaras," *The New York Times* (February 26, 1978), accessed online in the newspaper's archives. Kramer evidently was unaware of artists in the quilt art movement.

213 Ludy Straus, *Artist's Quilts: Quilts by Ten Contemporary Artists in Collaboration with Ludy Strauss* (N.p.: published in association with Harold I. Huttas [1981]).

214 Op. cit., p. 4. The exhibition toured for one year, mostly in California.

215 Ibid.

216 Op. cit., p. 5.

217 Charlotte Robinson, ed. *The Artist and the Quilt* (New York: Knopf, 1983), p. 10

218 Op. cit., pp. 35-36.

219 Al Paca, "Booknews," *Fiberarts Magazine* (Sept/Oct 1983), pp. 57-58.

220 Jean Ray Laury, "The Simplest Possible Creative Stitchery," *House Beautiful* (January 1960), pp. 52-55, 105-107.

221 William C. Seitz, *The Art of Assemblage* (New York: The Museum of Modern Art, 1961), p. 25. Seitz was writing about assemblage in general.

222 Hilton Kramer, "Art: Quilts Find a Place at the Whitney," *The New York Times* (July 3, 1971), accessed online in the newspaper's archives.

223 Lee Nordness, *Objects : USA* (New York: The Viking Press, 1970), p. 15.

224 Ibid.

225 Robert Shaw, *American Quilts: The Democratic Art, 1780-2007* (New York: Sterling, 2009), p. 274.

CONCLUSION

During the 1960s and 1970s, individuals began to create quilts as contemporary art from three directions: the world of stitchery and traditional quiltmaking; the academy of fine art; and, what might be viewed as the alternative and perhaps more rigorous academy of crafts, especially fibers and ceramics. For many artists, these three directions overlapped in very productive ways. Moreover, the training in basic design undertaken by artists in both crafts and art was proliferated as some of them became teachers, offering workshops, classes, and publications in which stitchers and quilters could gain aspects of this knowledge and apply them in their work. Thus quiltmaking in the United States began to develop a new sophistication, and with networking among various groups. The experimental work of these artists "helped to reshape quiltmaking aesthetically and conceptually."[226]

Quilt art was both a cause and effect—in different times and different places—of the artistic pluralism rampant in the U.S. during the 1970s. The pluralist aesthetics developing with and partly because of feminism "encouraged artists to consider any and all material and mediums acceptable and admissible to art."[227] Contemporary quilt art created between 1960 and 1980 illustrates the ubiquitous nature of visual art as a transcultural genre comprising a variety of media. By 1980, quilts had become a significant aspect of this phenomenon.

"Chuck Close [has] remarked, 'The 70s was a period nobody much liked, but the artists.' And the reason for this may be that 1970s art offered alternatives rather than final answers in a way that was stimulating and provocative but possibly not so satisfying in that it demanded that the audience do its own thinking and make its own choices."[228] There were very few critical rules concerning quilt art before the first *Quilt National* in 1979, and not many during the following decade. Viewers as well as artists had a heady sense of freedom with this new form of American art, whose themes explored the vagaries of contemporary culture within the historical validity of quilts as "women's work."

Quilt art from the 1960s and 1970s foreshadowed and contributed to the current global vogue for handmade work in which fiber plays a dominant role. Decades ago quilt artists were involved with a new artistic direction that extended beyond the limitations and definitions of "craft" and "art." Twenty-first-century art created through craft-related techniques and processes directed by hand "does not ignore technology but embraces it and employs it strategically with the handmade."[229] The same could be said of quilt art produced between 1960 and 1980, and of course later. Quilts set a precedent for the cultural value of handwork that only now is being properly appreciated in the art world.

226 Jacqueline M. Atkins, *Quilting Transformed: Leaders in Contemporary Quilting in the United States—The 20ᵗʰ Century and Beyond* (Tokyo: Tadanobu SETO, 2007), p. 3.

227 Laura Cottingham, *Seeing through the Seventies: Essays on Feminism and Art* (Amsterdam: G&B Arts International, 2000), p. 169.

228 Corinne Robins, *The Pluralist Era: American Art 1968-1981* (New York: Harper & Row, 1984), p. 237.

229 Shu Hung and Joseph Magliaro, eds., *By Hand: The Use of Craft in Contemporary Art* (New York: Princeton Architectural Press, 2007), p. 13.

BIBLIOGRAPHY

Works published before 1981:

15 Quilts for Today's Living. n.p.: Graphic Enterprises, 1968.

Alice Adams. "Frances Robinson," *Craft Horizons* 21 (May/June 1961), p. 42 [exhibition review].

Anders, Nedda C. *Appliqué Old and New, Including Patchwork and Embroidery.* New York: Dover Publications, 1976.

Ashbery, John. "The Johnson Collection at Cranbrook," *Craft Horizons* 30 (Mar./Apr. 1970), p. 35, 57 [exhibition review].

Auld, Rhoda L. *Molas.* New York: Van Nostrand Reinhold Company, 1977.

Avery, Virginia. *Big Book of Appliqué: For Quilts and Banners, Clothes, Hangings, Gifts, and More.* New York: Charles Scribner's Sons, 1978.

Beam, Ethel. "Streamlining the Art of Quilting," *House Beautiful* 98 (August 1956), pp. 74-77, 112.

Benberry, Cuesta. "Afro-American Women and Quilts," *Uncoverings* I (1980), pp. 64-67.

Beyer, Jinny. *Patchwork Patterns.* Mclean, VA: EPM Publications, 1979.

Bishop, Robert with Patricia Coblentz. *New Discoveries in American Quilts.* New York: E.P. Dutton, 1975.

Block, Jean Libman. "A Quilt is Built: Exhibition at the Museum of Contemporary Crafts," *Craft Horizons* 36 (April 1976), pp. 30-35 [exhibition review].

Britain, Judy, ed. *Vogue Guide to Patchwork & Quilting.* New York: Galahad Books (Condé Nast Publications), 1973.

Brown, Elsa. *Creative Quilting.* New York: Watson-Guptill, 1975.

Burton, Sandra. "Bad-Dream House," *Time Magazine* (20 March 1972, "Special Issue: The American Woman"), p 77.

Butler, Anne. *Embroidery Stitches*. New York: Praeger, 1970.

Chase, Judith. *Afro-American Art and Craft*. New York: Van Nostrand Reinhold Company, 1971.

Chase, Pattie. "Radka Donnell: Patchwork Quilts," *Fiberarts Magazine* (Sept/Oct 1980), pp. 76-77 [exhibition review].

Chase, Pattie with Mimi Dolbier. Foreword by Radka Donnell. *The Contemporary Quilt: New American Quilts and Fabric Art*. New York: E.P. Dutton, 1978.

Chatterton, Pauline. *Patchwork & Appliqué*. New York: The Dial Press, 1977.

Chicago, Judy and Susan Hill. *Embroidering Our Heritage: The Dinner Party Needlework*. Garden City, N.Y.: Anchor, 1980.

Christensen, Jo and Sonie Shapiro. *Appliqué and Reverse Appliqué*. New York, Sterling Publishing, 1974.

Colby, Averil. *Patchwork*. London and Newton Centre, MA: B.T. Batsford and Charles T. Branford, 1970.

Colby, Averil. *Quilting*. New York: Charles Scribner's Sons, 1971.

Constantine, Mildred and Jack Lenor Larsen, *Beyond Craft: The Art Fabric*. New York: Van Nostrand Reinhold Company [1973].

_____. *Wall Hangings*. New York: Museum of Modern Art, 1969 [exhibition catalogue].

Cooper, Patricia and Norma G. Buford. *The Quilters: Women and Domestic Art*. New York: Doubleday, 1977.

Cox, Patricia. *The Log Cabin Workbook*. Minneapolis: the Author, 1980.

Dean, Beryl. *Creative Appliqué*. New York: Watson-Guptill, 1970.

Dell, Twyla. "A Heart To Heart Talk with Jean Ray Laury," *Quilt World* (September/October 1979), pp. 10-12.

Dubois, Jean. "Crazy Quilt: A Collage in Color," *Design* 77 (Fall 1975), pp. 6-8.

Dudley, Taimi. *Patchwork: Quick and Easy Patchwork Using the Seminole Technique.* New York: Van Nostrand Reinhold Company, 1980.

Echols, Margit. *The New American Quilt: An Innovation in Contemporary Design.* Garden City, NY: Doubleday, 1976.

Evanoff, Betty. "Seminole Indian Patchwork," *Antiques Journal* (October 1975), pp. 50-51, 56.

Fabric Collage. New York: Museum of Contemporary Crafts, 1965.

Fanning, Robbie and Tony. *The Complete Book of Machine Quilting.* Radnor, PA: Chilton, 1980.

Field, June. *Creative Patchwork.* London: Pitman Publishing, 1974.

Finley, Ruth E. *Old Patchwork Quilts and the Women Who Made Them.* Philadelphia: J.B. Lippincott Company, 1929.

Gonsalves, Alyson Smith, ed. *Quilting & Patchwork: By the Editors of Sunset Books.* Menlo Park, CA: Lane Books, 1974.

Gross, Joyce. *A Patch in Time: A Catalog of Antique, Traditional, and Contemporary Quilts.* Mill Valley, CA: Joyce Gross, 1973.

Gutcheon, Beth. *The Perfect Patchwork Primer.* Baltimore: Penguin Books, 1974 [originally published 1973].

_____. "Quilt National '79," *Fiberarts Magazine* (Sept/Oct 1979), pp. 80-82 [exhibition review].

Gutcheon, Beth and Jeffrey. *The Quilt Design Workbook.* New York: Rawson Associates Publishers, 1976.

Guth, Jenny and Francis. "Venice: The Biennale," *Craft Horizons* 24 (Sept./Oct. 1964), p. 48 [exhibition review].

Hall, Carolyn V. *Stitched and Stuffed Art: Contemporary Designs for Quilts, Toys, Pillows, Soft Sculpture and Wall Hangings.* New York: Doubleday, 1974.

Hall, Carrie A. and Rose G. Kretsinger. *The Romance of the Patchwork Quilt in America.* New York: Bonanza Books, [1969].

Hammel, Lisa. "Quilts: A Folk Idiom That Has Come of Age," *New York Times* (April 9, 1976) [exhibition review].

Heard, Audrey and Beverly Pryor. *The Complete Guide to Quilting.* Des Moines: Creative Home Library, 1974 [in association with Better Homes and Gardens].

Hinson, Dolores. *A Quilter's Companion.* New York: Arco Publishing, 1966.

Holderness, Esther R. *Peasant Chic.* New York: Hawthorne Books, 1977.

Holland, Nina. *Pictorial Quilting.* South Brunswick, NJ: A.S. Barnes & Company, 1978.

Holstein, Jonathan. *Abstract Design in American Quilts.* New York: The Whitney Museum of American Art, 1971 [exhibition catalogue]. See below for a retrospective analysis of the exhibition published in 1991.

_____. *The Pieced Quilt: An American Design Tradition.* Greenwich, Conn.: Little, Brown, and Co., 1973.

Ickis, Marguerite. *The Standard Book of Quilt Making and Collecting.* New York: Dover Publications, 1959.

"In the Dark of the Swamp—Seminole Patchwork," *Fiberarts Magazine* (November 1977), pp. 38-40.

James, Michael. "Color in Quilts," *Quilter's Newsletter Magazine*, 1977, vol. 8 (no. 3), pp. 16-17. First article in a three-part series that began in March and ended in May.

_____. *The Quiltmaker's Handbook: A Guide to Design and Construction.* Mountain View, CA: Leone Publications, 1993 [originally published 1978].

Janeiro, Jan. "A Way of Working: Katherine Westphal and the Creative Process," *Fiberarts Magazine* (Nov/Dec 1980), pp. 35-37.

"Joy of Quilting," *Newsweek* 79 (January 10, 1972), p. 42.

Karlins, N.F. "New & Newer Quilts," *Quilter's Newsletter Magazine* 7 (August 1976), pp. 19-21 [exhibition review].

Kaufman, Glen. "Fiber" in "Young Americans: Fiber/Wood/Plastic/Leather," *Craft Horizons* 37 (June 1977), pp. 15, 69-70 [exhibition review, from images submitted].

Kramer, Hilton. "Art: Quilts Find a Place at the Whitney," *The New York Times* (July 3, 1971), accessed online in the newspaper's archives [exhibition review].

_____. "Bearden's 'Patchwork Cubism'," *The New York Times* (December 3, 1978), accessed online in the newspaper's archives [exhibition review].

_____. "The Daring Theatricality of Lucas Samaras," *The New York Times* (February 26, 1978), accessed online in the newspaper's archives.

Lane, Maggie. *Maggie Lane's Oriental Patchwork.* New York: Charles Scribner's Sons, 1978.

Larsen, Judith LaBelle and Carol Waugh Gull. *The Patchwork Quilt Design & Coloring Book.* Piscataway, NJ: New Century Publishers, 1977.

Laury, Jean Ray. *Applique Stitchery.* New York: Van Nostrand Reinhold Company, 1966.

____. "The Simplest Possible Creative Stitchery," *House Beautiful* (January 1960), pp. 52-55, 105-107.

_____. *Quilts & Coverlets: A Contemporary Approach.* New York: Van Nostrand Reinhold Company, 1970.

Leman, Bonnie. *Quick and Easy Quilting.* Great Neck, NY: Hearthside Press, 1972.

Lithgow, Marilyn. *Quiltmaking and Quiltmakers.* New York: Funk & Wagnalls, 1974.

Mainardi, Patricia. "Great American Cover-Ups," *Art News* 73 (Summer 1974), pp. 30-32.

_____. "Quilts: The Great American Art," *Feminist Art Journal* 2 (1973), pp. 1, 18-23.

_____. *Quilts: The Great American Art.* San Pedro, Calif.: Miles, 1978 [first published in the *Feminist Art Journal*, see above].

Malarcher, Patricia. "The Appliqué Art of Nell Booker Sonnemann," *Fiberarts Magazine* (May/June 1980), pp. 24-27.

Malcolm, Janet. "About the House," *New Yorker* 50 (September 2, 1974), pp. 68-73.

Marston, Doris. *Exploring Patchwork.* New York: Doubleday, 1971.

_____. *Patchwork Today: A Practical Introduction*. Newton Centre, MA: Charles T. Branford, 1968.

Martins, Rachel. *Modern Patchwork*. New York: Doubleday, 1971.

McCall's Contemporary Quilting. New York: The McCall Pattern Company, 1975.

McCall's Needlework Treasury: A Learn and Make Book. New York: Random House, 1964.

McCall's Quilt It! Book II. New York: The McCall Pattern Company, 1974.

McCall's Super-book of Quilting. New York: The McCall Pattern Company, 1976.

McKain, Sharon. *The Great Noank Quilt Factory: How to Make Quilts and Quilted Things*. New York: Random House, 1974.

McKim, Ruby Short. *One Hundred and One Patchwork Patterns*. New York: Dover Publications, 1962.

Meisel, Alan. "Letter from San Francisco," *Craft Horizons* 26 (June 1966), pp. 87-88 [exhibition review].

Metzler-Smith, Sandra J. "Quilts in Pomo Culture," *Uncoverings* 1 (1980), pp. 41-47.

Miller, Stephanie. *Creative Patchwork*. New York: Crown Publishers, 1971.

Nadelman, Cynthia. "Fabric in Art," *Art News* 79 (September 1980), pp. 244-247 [exhibition review].

Nemy, Enid. "If Everyone Wears Patchwork, Summer Will Be a Crazy Quilt," *New York Times* (May 27, 1969).

New, Azalea Thorpe. "Young Americans 1969," *Craft Horizons* 29 (July/Aug. 1969), p. 9 [exhibition review].

"A New Look at Trapunto," *Quilters Newsletter Magazine* 10 (July 1979), pp. 16-19.

Newman, Thelma R. *Quilting, Patchwork, Appliqué, and Trapunto: Traditional Methods and Original Designs*. New York: Crown Publishers, 1974.

Nochlin, Linda. "Miriam Schapiro: Recent Work," *Arts Magazine* 48 (Nov. 1973), pp. 38-41.

Nordness, Lee. *Objects : USA*. New York: The Viking Press, 1970.

Orlofsky, Patsy and Myron. *Quilts in America.* New York: McGraw-Hill, 1974.

Park, Betty. "The Woven Collages of Arturo Sandoval," *Fiberarts Magazine* (Sept/Oct 1979), pp. 70-73.

Patera, Charlotte. *The Applique Book.* New York: Creative Home Library, 1974.

Pforr, Effie Chalmers. *Progressive Farmer Award Winning Quilts.* Birmingham: Oxmoor House, 1974.

Porcella, Yvonne. *Pieced Clothing.* Modesto, CA: Porcella Studios, 1980.

"Quilts as Art," *Newsweek* 22 (August 2, 1943), p. 91 [review of exhibition of original quilts by Bertha Stenge].

Reif, Rita. "Quilting Is No Longer Just Another Pastime," *New York Times* (April 25, 1972). ht

Renshaw, Donna. *Quilting, A Revived Art: Cultivate the Art of Making Something with Your Own Hands.* Los Altos, CA: the author [c. 1975].

Rickey, Carrie. "Art of Whole Cloth," *Art in America* 79 (November 1979), pp. 72-83.

Rossbach, Ed. "Ed Rossbach Says," *Craft Horizons* (June 1976), pp. 23-25, 80.

Rowland, Amy Zaffarano. "Building on Experience: Virginia Jacobs' Fabric Constructions," *Fiberarts Magazine* (July/Aug 1980), pp. 39-43.

Safford, Carlton L. and Robert Bishop. *America's Quilts and Coverlets.* New York: E.P. Dutton, 1972.

Sawyer, Kenneth. "Fabric Collage," *Craft Horizons* 25 (Mar./April 1965), pp. 16-21, 51 [exhibition review].

Schapiro, Miriam. "Education of Women as Artists: Project *Womanhouse*," *Art Journal* 31 (no. 3, Spring 1972), pp. 268-270.

Schoenfeld, Susan. *Pattern Design for Needlepoint and Patchwork.* New York: Van Nostrand Reinhold Company, 1974.

"Sew Your Own Magazine Cover Quilt," *Saturday Evening Post* 250 (January 1978), pp. 22-25 [illustrates pictorial quilts by Chris Wolf Edmonds].

Shapiro, David. "American Quilts," *Craft Horizons* 31 (Dec. 1971), pp. 42-44, 72 [exhibition review].

"Short Cuts for Quilters," *Better Homes & Gardens* 41 (January 1963), pp. 80-82 [quilted objects designed by Jean Ray Laury].

Seitz, William C. *The Art of Assemblage.* New York: The Museum of Modern Art, 1961.

Shirey, David L. "A Bright New Wrinkle for Quilts," *The New York Times* (February 27, 1977), accessed online in the newspaper's archives [exhibition review].

Slivka, Rose. "The New Tapestry," *Craft Horizons* 23 (Mar/April 1963), p. 10, 48 [exhibition review].

Smith, Paul. *Fabric Collage.* New York: Museum of Contemporary Crafts, [1965, exhibition catalogue].

Svennas, Elsie. *Advanced Quilting.* New York: Charles Scribner's Sons, 1980.

_____. *Patchcraft: Designs, Material, Technique.* New York: Van Nostrand Reinhold Company, 1972 [originally published 1971, in Swedish].

Tanenhaus, Ruth Amdur. *The New American Quilt.* New York: Museum of Contemporary Crafts, 1976 [exhibition catalogue].

Timmins, Alice. *Introducing Patchwork.* New York: Watson-Guptill, 1968.

Van Dommelen, David B. *Decorative Wall Hangings: Art with Fabric.* (New York): Funk & Wagnalls Company, Inc., 1962.

"Wall Hangings: Part One," *Interiors* (May 1961), pp. 118-121.

"Wall Hangings: Part Two," *Interiors* (June 1961), pp. 120-125.

West, Virginia. "New Directions in Fabric Design," *Craft Horizons* 37 (June 1977), p. 60 [exhibition review].

Wilding, Faith. *By Our Own Hands: The Women Artist's [sic] Movement, Southern California 1970-1976.* Santa Monica: Double X, 1977.

Wilson, Erica. *Erica Wilson's Quilts of America.* Birmingham, AL: Oxmoor House, 1979 [illustrating quilts from the Great American Quilt Contest].

Woolley, Jackson, in "What Criteria for the Crafts," *Crafts Horizon* 20 (March/April 1960), p. 38.

Wooster, Ann-Sargent. Quiltmaking: *The Modern Approach to a Traditional Craft*. New York: Drake Publishers, 1972.

Zimmerman, Sandra. *Sewn, Stitched & Stuffed.* New York: Museum of Contemporary Crafts, 1973.

Works published after 1980:

Adamson, Glenn. *Thinking Through Craft*. Oxford and New York: Berg, 2007.

Albacete, M.J., Sharon D'Atri, and Jane Reeves. *Ohio Quilts: A Living Tradition*. Canton, OH: The Canton Art Institute, 1981 [exhibition catalogue].

Allan, Lois. "'The Cancer Project' Provides Psychic Healing," *ProWOMAN Magazine* (October/November 1990), pp. 44-45 [Marie Lyman exhibition review].

Artists' Quilts: Quilts by Ten Contemporary Artists in Collaboration with Ludy Strauss. N.p.: published in association with Harold I. Huhas, 1981 [exhibition catalogue].

Atkins, Jacqueline M. *Quilting Transformed: Leaders in Contemporary Quilting in the United States—The 20th Century and Beyond.* Tokyo: Tadanobu SETO, 2007. (In Japanese and English.)

Auther, Elissa. Classification and Its Consequences: The Case of 'Fiber Art,'" *American Art* 16 (Autumn 2002), pp. 2-9.

_____. *String, Felt, Thread and the Hierarchy of Art and Craft in American Art, 1960-1980*. Minneapolis: University of Minnesota Press, 2010.

Bass, Ruth. "Exhibition Review: Edward Larson," *Art News* (April 1981), p. 194.

Bavor, Nancy. "The California Art Quilt Movement: From the Summer of Love to *The Art Quilt* Exhibition." M.A. thesis project, University of Nebraska Lincoln (Michael James, advisor), 2010.

Behuniak-Long, Susan. "Preserving the Social Fabric: Quilting in a Technological World." In Cheryl B. Torsney and Judy Elsley, eds. *Quilt Culture: Tracing the Pattern*. Columbia and London: University of Missouri Press, 1994, pp. 151-168.

Benberry, Cuesta, with Joyce Gross. *20th Century Quilts 1900-1970: Women Make Their Mark*. Paducah: American Quilter's Society, 1997 [exhibition catalogue].

_____. *Always There: The African-American Presence in American Quilts* [exhibition catalogue]. Louisville: Kentucky Quilt Project, 1992.

Bernick, Susan E. "A Quilt Is an Art Object when It Stands Up like a Man." In Cheryl B. Torsney and Judy Elsley, eds. *Quilt Culture: Tracing the Pattern*. Columbia and London: University of Missouri Press, 1994, pp. 134-150.

Bishop, Robert. "Robert Bishop on Quilts as Art," *Architectural Digest* (July 1983): 32-38.

Broude, Norma and Mary D. Garrard. "Conversations with Judy Chicago and Miriam Schapiro," in Norma Broude and Mary D. Garrard, eds. *The Power of Feminist Art: The American Movement of the 1970s, History and Impact*. New York: Harry N. Abrams, 1994, pp. 66-85.

Cabeen, Lou. "Pattern of Thought: A Look at Ethnic Influences on the Creative Process," *Fiberarts Magazine* (Jan/Feb 1991), pp. 29-33.

Chicago, Judy. *Through the Flower: My Struggle as a Woman Artist*. New York and London: Penguin Books, 1993.

Colchester, Chloë. *The New Textiles: Trends and Traditions*. New York: Rizzoli, 1991.

Contemporary Quilts from the James Collection. Helen Cullinan, foreword; Penny McMorris, introduction; Ardis James, catalogue descriptions. Paducah: American Quilter's Society, 1995 [based on a 1995 exhibit at the Museum of the American Quilter's Society curated by Penny McMorris].

Cottingham, Laura. *Seeing through the Seventies: Essays on Feminism and Art*. Amsterdam: G&B Arts International, 2000.

Danto, Arthur C. *The Transfiguration of the Commonplace: A Philosophy of Art*. Cambridge: Harvard University Press, 1981.

Davis, Marilyn. "The Contemporary American Quilter: A Portrait," *Uncoverings* 2 (1981), pp. 45-51.

Donnell, Radka. *Quilts as Women's Art: A Quilt Poetics*. North Vancouver: Gallerie, 1990.

Elsley, Judy. "*The Color Purple* and the Poetics of Fragmentation." In Cheryl B. Torsney and Judy Elsley, eds. *Quilt Culture: Tracing the Pattern*. Columbia and London: University of Missouri Press, 1994, pp. 68-83.

Farrington, Lisa E. Foreword by David C. Driskell. *Faith Ringgold*. San Francisco: Pomegranate, 2004.

Ferrero, Pat, Elaine Hedges, and Julie Silber. *Hearts and Hands: The Influence of Women and Quilts on American Society*. San Francisco: Quilt Digest, 1987.

Freeman, Roland L. *A Communion of the Spirits: African-American Quilters, Preservers, and Their Stories.* Nashville: Rutledge Hill Press, 1996.

Frye, L. Thomas, ed. *American Quilts: A Handmade Legacy.* Oakland: The Oakland Museum, 1981 [exhibition catalogue].

Gee's Bend: The Women and Their Quilts. Atlanta: Tinwood Books, in association with the Museum of Fine Arts, Houston, 2002 [exhibition catalogue].

Gouma-Peterson, Thalia and Patricia Mathews. "The Feminist Critic of Art History," *The Art Bulletin* 69 (no. 3, Sept. 1987), pp. 326-357.

Gouma-Peterson, Thalia. *Miriam Schapiro: Shaping the Fragments of Art and Life.* New York: Harry N. Abrams, 1999.

Halpern, Nancy. *Northern Comfort: Three Hundred and Fifty Years of New England Quilts* (unpublished manuscript, completed in 1983).

Harper, Paula. "The First Feminist Art Program: A View from the 1980s," *Signs* 10 (no. 4: *Communities of Women*, Summer 1985), pp. 762-781.

Hicks, Kyra E. *Black Threads: An African American Quilting Sourcebook.* Jefferson, NC, and London: McFarland & Company, 2003.

Hillard, Van E. "Census, Consensus, and the Commodification of Form: *The NAMES Project Quilt.*" In Cheryl B. Torsney and Judy Elsley, eds. *Quilt Culture: Tracing the Pattern.* Columbia and London: University of Missouri Press, 1994, pp. 112-124.

Holstein, Jonathan. *Abstract Design in American Quilts: A Biography of an Exhibition* [re-creation of the 1971 Whitney exhibition, with appendixes including the original catalogue essay and exhibition schedule of the traveling shows]. Foreword by Shelly Zegart. Louisville: The Kentucky Quilt Project, 1991. (Number 890 of 1000 specially bound and boxed copies, signed by the author.)

_____. "The Whitney and After ... What's Happened to Quilts," *Clarion* (Spring/Summer 1986): 80-85.

Hung, Shu and Joseph Magliaro, eds. *By Hand: The Use of Craft in Contemporary Art.* New York: Princeton Architectural Press, 2007.

Ilse-Neuman, Ursula. Curator's statement for the exhibition *Art Quilts from the Collection of the Museum of Arts & Design* (2006, at the American Textile History Museum in Lowell, MA). http://www.athm.org/exhibitions_artquilts.htm (March 31, 2006).

James, Michael. "Beyond Tradition: The Art of the Studio Quilt," *American Craft* (February/ March 1985), pp. 16-22.

_____. *The Second Quiltmaker's Handbook*. Mountain View, CA: Leone Publications, 1981.

Janeiro, Jan. "Before the '60s: The Early History of Bay Area Textiles," *Fiberarts Magazine* (Jan/Feb 1993), pp. 32-35.

Koplos, Janet. "When Is Fiber Art 'Art'?" *Fiberarts Magazine* (Mar/Apr 1986), pp. 34-35. Available online at: http://www.fiberarts.com/article_archive/critiquefiberart_art.asp

Lauter, Estella. "Re-Enfranchising Art: Feminist Interventions in the Theory of Art," *Hypatia* 5 (Summer 1990), pp. 91-106. (Issue on "Feminism and Aesthetics.")

Lenkowsky, Kate. *Contemporary Quilt Art: An Introduction and Guide*. Bloomington: Indiana University Press, 2008.

Leon, Eli. *The Management of Irregularities in African Textiles and African American Quilts*. Davenport, Iowa: Figge Museum of Art, 2006.

_____. *Who'd A Thought It: Improvisation in African-American Quiltmaking*. San Francisco: San Francisco Craft and Folk Art Museum, 1987.

Lippard, Lucy. *Mixed Blessings: New Art in a Multicultural America*. New York: Pantheon, 1990.

_____. "Up, Down, and Across: A New Frame for New Quilts." In Charlotte Robinson, ed. *The Artist and the Quilt*. New York: Knopf, 1983, pp. 32-43.

Livingstone, Joan and John Ploof, eds. *The Object of Labor: Art, Cloth, and Cultural Production*. Chicago and London: School of the Art Institute of Chicago Press and MIT Press, 2007.

Lucie-Smith, Edward. *Art in the Seventies*. Ithaca: Cornell University Press, 1980.

Lyman, Marie. "Boxes and Robes: Wrapped and Unwrapped Forms," in *Delectable Mountains*. Portland: Morning Light Studio, 1982, pp. (5-8).

Mattera, Joanne, ed. *The Quiltmaker's Art: Contemporary Quilts and Their Makers*. Asheville, NC: Lark Books, 1982.

Mainardi, Patricia. "Quilt Survivals and Revivals," *Arts Magazine* (May 1988), pp. 49-53.

Makowski, Colleen Laham. *Quilting 1915-1983: An Annotated Bibliography*. Metuchen, NJ: The Scarecrow Press, 1985.

Malarcher, Patricia. "Nell Battle Booker Sonnemann," in *Nell Battle Booker Sonnemann*. [Greenville, NC: East Carolina University, 2007, exhibition catalogue].

Marilyn Henrion: Noise. [New York: published by the artist, 2007, exhibition catalogue.]

Mazloomi, Carolyn. *Spirits of the Cloth: Contemporary African American Quilts*. Preface by Faith Ringgold, Foreword by Cuesta Benberry. New York: Clarkson Potter, 1998.

McMorris, Penny and Michael Kile. *The Art Quilt*. San Francisco: Quilt Digest, 1984.

Michael James: Quiltmaker. Fabric Constructions: The Art Quilt. Worcester, MA: The Worcester Craft Center, 1983 [exhibition catalogue].

Nadelstern, Paula with LynNell Hancock. *Quilting Together: How to Organize, Design, and Make Group Quilts*. New York: Crown Publishers, 1988.

Nelson, Cyril and Carter Houck. *The Quilt Engagement Calendar Treasury* [1975 to 1982, with 1976 not exclusively quilts but rather folk art and fine crafts in general]. New York: E.P. Dutton, 1982.

The New American Quilt. Asheville, NC: Lark Books, 1981 [exhibition catalogue, illustrating quilts from the 1979 and 1981 Quilt Nationals].

"Not So Crazy Quilts," *Art News* 81 (March 1982), pp. 16-19 [exhibition review].

Olsen, Kirstin. *Southwest By Southwest: Native American and Mexican Designs for Quilters*. New York: Sterling Publishing Company, 1991.

A Patchwork Garden. Chattanooga, TN: The Hunter Museum of Art, 1981 [exhibition catalogue].

Peterson, Karin Elizabeth, "Discourse and Display: The Modern Eye, Entrepreneurship, and the Cultural Transformation of the Patchwork Quilt," *Sociological Perspectives* 46 (no. 4, Winter 2003), pp. 461-490.

Price, Sandra. "Jan Myers-Newbury: The Color of Tension," *Fiberarts Magazine* (Nov/Dec 1990), p. 25.

Pritchard, Gayle. *Uncommon Threads: Ohio's Art Quilt Revolution*. Athens: Ohio University Press, 2006.

Quilt National 1979. Web site containing an introduction, list of artists, and images of the quilts; there was no published catalogue of the exhibition in 1979. http://www.quiltnational.com/

Quilter's Newsletter Magazine, Special 15th Anniversary Issue, 1984.

Ramsey, Bets. "Art and Quilts, 1950-1970," *Uncoverings* 14 (1993), pp. 9-39.

Raven, Arlene. *Crossing Over: Feminism and Art of Social Concern*. Ann Arbor and London: U.M.I. Research Press, 1988.

_____. "*Womanhouse*," in Norma Broude and Mary D. Garrard, eds. *The Power of Feminist Art: The American Movement of the 1970s, History and Impact*. New York: Harry N. Abrams, 1994, pp. 48-65.

Reif, Rita. "Lee Nordness, 72, Art Dealer Who Promoted Crafts," *The New York Times* (May 23, 1995), accessed online in the newspaper's archives.

Robins, Corinne. *The Pluralist Era: American Art 1968-1981*. New York: Harper & Row, 1984.

Robinson, Charlotte, ed. *The Artist and the Quilt*. New York: Knopf, 1983 [exhibition catalogue].

Robinson, Sharon. *Contemporary Quilting*. Worcester, MA: Davis Publications, 1982.

Rush, Barbara with Lassie Wittman. *The Complete Book of Seminole Patchwork*. Seattle: Madrona Publishers, 1982.

Schapiro, Miriam, and Faith Wilding. "Cunts/Quilts/Consciousness," *Heresies* 1988: 1-17.

_____. "Geometry and Flowers." In Charlotte Robinson, ed. *The Artist and the Quilt*. New York: Knopf, 1983, pp. 26-31.

Schor, Mira. "A Plague of Polemics," *Art Journal* 50 (no. 4, Winter 1991), pp. 36-41.

_____. "The Feminist Art Programs at Fresno and Calarts, 1970-75," in Norma Broude and Mary D. Garrard, eds. *The Power of Feminist Art: The American Movement of the 1970s, History and Impact*. New York: Harry N. Abrams, 1994, pp. 32-47.

Shaw, Robert. *American Quilts: The Democratic Art 1780-2007*. New York: Sterling Publishing Company, 2009.

_____. *The Art Quilt*. Southport, CT: Hugh Lauter Levin Associates, 1997.

_____. "Five Decades of Unconventional Quilts" [1960s], *Quilter's Newsletter Magazine*, 2004, vol. 35 (no. 1), pp. 44-47.

_____. *Quilts: A Living Tradition*. Southport, CT: Hugh Lauter Levin Associates. 1995.

Sider, Sandra. "Femmage: The Timeless Fabric Collage of Miriam Schapiro," *Fiberarts Magazine* (Summer 2005), p. 50-53.

_____. "Folk-Art Aesthetics and American Art Quilts," *Fiberarts Magazine* (Nov/Dec 2003), p. 32-36.

_____. "My mother was not a quilter," in *Jean Ray Laury: A Life By Design*. San Jose: San Jose Museum of Quilts & Textiles, 2006, pp. 4-5 [exhibition catalogue].

_____. "Origins of American Art Quilts: Politics and Technology," *Proceedings of the Textile History Forum 2007*, pp. 5-13.

_____. *WOMANHOUSE: Cradle of Feminist Art, January 30 — February 28, 1972*. In the Art Spaces Archive Project: http://as-ap.org/sider/resources.cfm.

Smith, Barbara. *Celebrating the Stitch: Contemporary Embroidery of North America*. Newtown, CT: Taunton Press, 1991. [Most of the works depicted were made in the 1980s.]

Straus, Ludy. Foreword by Jonathan Holstein. *Artist's Quilts: Quilts by Ten Contemporary Artists in Collaboration with Ludy Strauss*. N.p.: published in association with Harold I. Huttas (1981).

Thompson, Robert Farris. "From the First to the Final Thunder: African-American Quilts, Monuments of Culture Assertion." In Eli Leon, *Who'd A Thought It: Improvisation in African-American Quiltmaking*. San Francisco: San Francisco Craft and Folk Art Museum, 1987, pp. 12-21.

Wahlman, Maude Southwell. *Signs & Symbols: African Images in African American Quilts*. Atlanta: Tinwood Books, 2001.

Weidlich, Lorre M. "Quilts and Art: Value Systems in Conflict," *Studio Art Quilt Associates Newsletter*, vol. 6 (no. 2), 1996, pp. 1, 8-9.

LIST OF ILLUSTRATIONS

Teresa Barkley. *Denim Quilt* (1972, 94 x 77 in.), photo by Karen Bell. Fig. 17, page 39.

Elizabeth Barton. (Screen-printed jeans, c.1970-72, 40 x 24 in.), photo by the artist. Fig. 34, page 64.

Sue Benner. *Seminiferous Tubulae: mature* (1980, 24 x 21 in.). Fig. 26, page 54.

Helen Bitar. *Mountain in the Morning* (1976, 106 x 83 in.), photo by the artist. Fig. 6, page 9.

Tafi Brown. *The American Wing VIII* (1976, 86 x 59 in.), photo by Michael Gordon. Fig. 10, page 19.

Joyce Marquess Carey. *Closeup* (1976, 45 x 45 in.), photo by the artist. Fig. 50, page 84.

Jane Burch Cochran. *Indian Madonna* (1980, 12 x 12 in.), photo by the artist. Fig. 32, page 62.

Rhoda Cohen. *Blue Rider* (late 1970s). Fig. 42, page 77.

Sas Colby. *Figure Quilt* (detail, 1975), photo by the artist. Fig. 31, page 59.

Judith Content. *Sweltering Sky Kimono* (1982, 61 x 52 in.), photo by James Dewrance. Fig. 13, page 33.

Nancy Crow. *Whirligig* (1975, 92 x 72 in.). Fig. 39, page 69.

Michael Cummings. *Time and Space* (1976, 48 x 72 in.). Fig. 23, page 51.

Radka Donnell. *Das Grosse T* (1974, 100 x 84 in.). Fig. 16, page 37.

Sylvia H. Einstein. *Pattern of Least Regret* (1978, 65 x 45 in.), photo by Sam Sweezy. Fig. 15, page 36.

Nancy Erickson. *Red Rain #2: Rabbit Alone* (1978, 108 x 84 in.), photo by Jon Schulman. Fig. 25, page 53.

Caryl Bryer Fallert. *Feather Study #10* (detail, 1999), photo by the artist. Fig. 37, page 67.

Caryl Bryer Fallert. *Untitled Painting #1* (1971, 24 x 30 in.), photo by the artist. Fig. 41, page 77.

Beth Gutcheon. *Pace Victoria* (1972, 50 x 39 in.), photo by Bevan Davies. Frontispiece (facing title-page).

Nancy Halpern. *Crow Quilt* (1976, 96 x 84 in.), photo by the artist. Fig. 43, page 78.

David Hornung. *Red Construction* (1980, 72 x 60 in.), photo by the artist. Fig. 48, page 83.

Michael James. *Medallion* (painting, 1973, 42 x 48 in.), photo by the artist. Fig. 49, page 84.

Michael James. *Razzle-Dazzle* (1975, 96 x 84 in.), photo by the artist. Fig. 2, page 3.

Ed Larson. *Girls, Girls, Girls* (1970s, 45 x 32 in.), quilted by Carolyn Crusian. Fig. 1, page 1.

Jean Ray Laury. *Leaky Kaleidoscope* (1978, 23.5 x 23.5 in.), photo by Stan Bitters. Fig. 9, page 15.

Jean Ray Laury. *Tom's Quilt* (1956, 74 x 50 in.), photo by Stan Bitters. Fig. 5, page 8.

M. Joan Lintault. Untitled (1969, 81 x 44 in.), photo by the artist. Fig. 12, page 31.

Debra Lunn. *Counterpoint* (1979, 76 x 92 in.). Fig. 47, page 81.

Marie Lyman. *Dream of White Horses: Rock, Sky, Sea* (1975, 81 x 51 in.), photo by Jim Lommasson. Fig. 3, page 4.

Marie Lyman. *Robe #3* (late 1970s, 28 x 42 in.), photo by Jim Lommasson. Fig. 14, page 34.

Linda MacDonald. *Blues* (1976, 90 x 80 in.), photo by Robert Comings. Fig. 11, page 20.

Terrie Hancock Mangat. *Giraffes* (1978, 96 x 86 in.). Fig. 20, page 42.

Susan Shie & James Acord. *The Teapot/High Priestess: Card #2 in The Kitchen Tarot* (1998, 87 x 55 in.). Fig. 45, page 80.

Nell Booker Sonnemann. *Woman Clothed with the Sun* (1972, 72 x 30 x 24 in.), photo by Seth Tice-Lewis. Fig. 8, page 11.

Molly Upton. *Watchtower* (1975, 90 x 110 in.). Fig. 4, page 5.

Katherine Westphal. *Puzzle of the Floating World – No. 3* (1975, 83 x 69 in.). Fig. 19, page 40.

Katherine Westphal. *Triennale* (1964). Fig. 40, page 71.

Timeline, c. 1960-c. 1980: Influential Publications and Major Exhibitions

1958 *Patchwork* by Averil Colby

1959 *The Standard Book of Quiltmaking and Collecting* (reprint) by Marguerite Ickis

1961 Exhibition: *The Art of Assemblage*, Museum of Modern Art, New York

1961 Exhibition: *Frances Robinson* (solo show), Museum of Contemporary Crafts

1962 *101 Patchwork Patterns* (reprint) by Ruby McKim

1962 *Decorative Wall Hangings: Art with Fabric* by David van Dommelen

1963 Exhibition: *Woven Forms*, Museum of Contemporary Crafts

1963 *McCall's Contemporary Quilting* first published

1964 Exhibition: *Venice Biennale*

1965 Exhibition: *Optical Quilts*, Newark Museum, New Jersey

1965 Exhibition: *Fabric Collage*, Museum of Contemporary Crafts

1966 Exhibition: *Paintings in Thread*, Nik Krevitsky (solo show), Temple Emanu-El, San Francisco

1966 *Applique Stitchery* by Jean Ray Laury

1969 Exhibition: *Young Americans*, University of New Mexico Art Gallery, traveled to the Museum of Contemporary Crafts

1969 Exhibition: *Wall Hangings*, Museum of Modern Art, New York

1969 *Quilter's Newsletter* begins publication

1969 Exhibition: *Objects : USA*, Smithsonian, and touring

1970 *Quilts and Coverlets: A Contemporary Approach* by Jean Ray Laury

1971 Exhibition: *Abstract Design in American Quilts*, Whitney Museum, and touring

1972 *Quiltmaking: The Modern Approach to a Traditional Craft* by Ann-Sargent Wooster

1973 Exhibition: *Sewn, Stitched & Stuffed*, Museum of Contemporary Crafts

1973 *Beyond Craft: The Art Fabric* by Mildred Constantine and Jack Lenor Larsen

1973 *Quilting and Patchwork* by the editors of Sunset Books

1973 *The Perfect Patchwork Primer* by Beth Gutcheon

1974 *The Complete Guide to Quilting* by Audrey Heard and Beverly Pryor

1974 *Quilting, Patchwork, Appliqué, and Trapunto* by Thelma R. Newman

1974 *Stitched and Stuffed Art* by Carolyn Vosburg Hall

1975 *Quilting, A Revived Art: Cultivate the Art of Making Something with Your Own Hands* by Donna Renshaw (published c. 1975)

1975 *Fiberarts Magazine* begins publication

1975 *Creative Quilting* by Elsa Brown

1975 Exhibition: quilts by Radka Donnell, Susan Hoffman, and Molly Upton, Carpenter Center for the Arts, Harvard University

1975 Exhibition: *Bed and Board*, DeCordova Museum, Lincoln, Massachusetts

1975 Exhibition: quilts by Susan Hoffman and Molly Upton, Kornblee Gallery, New York

1976 *The Quilt Design Workbook* by Beth and Jeffrey Gutcheon

1976 Exhibition: *Quilts '76*, Cyclorama Building, The Boston Center for the Arts (173 quilts by 163 artists)

1976 *The New American Quilt: An Innovation in Contemporary Quilt Design* by Margit Echols

1976 *Principles of the Stitch* by Lilo Markrich

1976 Exhibition: *Quilts in Women's Lives*, San Francisco Art Institute

1976 Exhibition: *Finger Lakes Bicentennial Quilt Exhibit*, and quilt conference, Ithaca, New York

1976 Exhibition: *The New American Quilt*, The Museum of Contemporary Crafts, and touring

1977 *The Patchwork Quilt Design & Coloring Book* by Judith LaBelle Larsen and Carol Waugh Gull

1977 *Quilters' Journal* begins publication (until 1987)

1977 Exhibition: *New Directions in Fabric Design*, Towson State University, Baltimore

1977 *Patchwork & Appliqué* by Pauline Chatterton

1977 Exhibition: *Young Americans—Fiber/Wood/Plastic/Leather*, Southeastern Center for Contemporary Art, Winston-Salem, North Carolina, then touring

1978 *The Quiltmaker's Handbook: A Guide to Design and Construction* by Michael James

1978 *The Contemporary Quilt: New American Quilts and Fabric Art* by Pattie Chase and Mimi Dolbier

1979 Exhibition: *Quilt National*, the Dairy Barn, Athens, Ohio

1979 Exhibition: *The Dinner Party*, Museum of Modern Art, San Francisco

1979 *Erica Wilson's Quilts of America* (the Great Quilt Contest)

1979 *Patchwork Patterns* by Jinny Beyer

1980 *Advanced Quilting* by Elsie Svennas

1980 The journal *Uncoverings* first published by the American Quilt Study Group

1981 *The Second Quiltmakers Handbook: Creative Approaches to Contemporary Quilt Designs* by Michael James

1981 Exhibition: *Quilt National*

APPENDIX II

SURVEY SENT TO ARTISTS, 2001-2008

ARTIST SURVEY

Please use the back of each sheet if needed or add additional sheets. Feel free to skip any questions that do not apply or that you do not wish to answer. This should be fun, not a chore. The information indicated as "confidential" would be used only in a general way in my introduction and would not be linked with your name. These surveys will be destroyed after my book is written.

Name _____

Previous name(s) _____

Date and place of birth _____

Main activities during 1950-1960:

1960-1965:

1965-1970:

1970-1975:

1975-1980:

Please describe your activities between 1980 and today:

If you have taken several classes or have a degree in literature, creative writing, music, fine arts, or art history, or a certificate involving crafts or another field using your hands, please give date(s) and institution(s).

Please describe the three most important classes or workshops you have taken during your development as a quilt artist, with contact information for the teachers if you happen to have it.

List any quilt or fiber art exhibitions between 1960 and 1980 that remain strong in your visual memory, giving year and venue if you remember it.

What is your most memorable event or "snapshot" memory from the 1960s? (This might be a completely personal event.)

From the 1970s?

From the 1980s?

If you were active in national politics during the 1960s, or reacting to national politics, please describe what you were doing.

If you experimented with psychedelic drugs, please explain any effects on your art. (confidential)

If you listen(ed) to popular music from the 1960s fairly often, can you explain why? And who are your favorite 1960s musicians and bands?

If you work(ed) with any sort of music playing in your studio, please elaborate.

If you were active in environmental politics during the 1970s, please elaborate.

If you have were active in feminist or racial politics between 1960 and 1980, please elaborate.

If you come from a family of traditional quiltmakers, please summarize your family history: If your family has NO quilting traditions, please say so.

Please describe any foreign travel between 1960 and 1980 that has influenced your work.

If you use or have used any materials or processes in your art that were developed between 1960 and 1980, please elaborate.

Anything else you want to add?

INDEX OF NAMES

Photoart Publishing produced this book via CreateSpace, with Perpetua as the interior font. The company operates by on-demand manufacture, producing units only as ordered, to reduce excess production and waste. The acid-free interior paper stock was supplied by an FSC-certified provider, to help protect our environment.

5866686R0

Made in the USA
Charleston, SC
13 August 2010